THUNDER BAY
P · R · E · S · S

THE GREATEST BRICK BUILDS

AMAZING CREATIONS IN LEGO®

INTRODUCTION BY
NATHAN SAWAYA

THUNDER BAY
P · R · E · S · S

San Diego, California

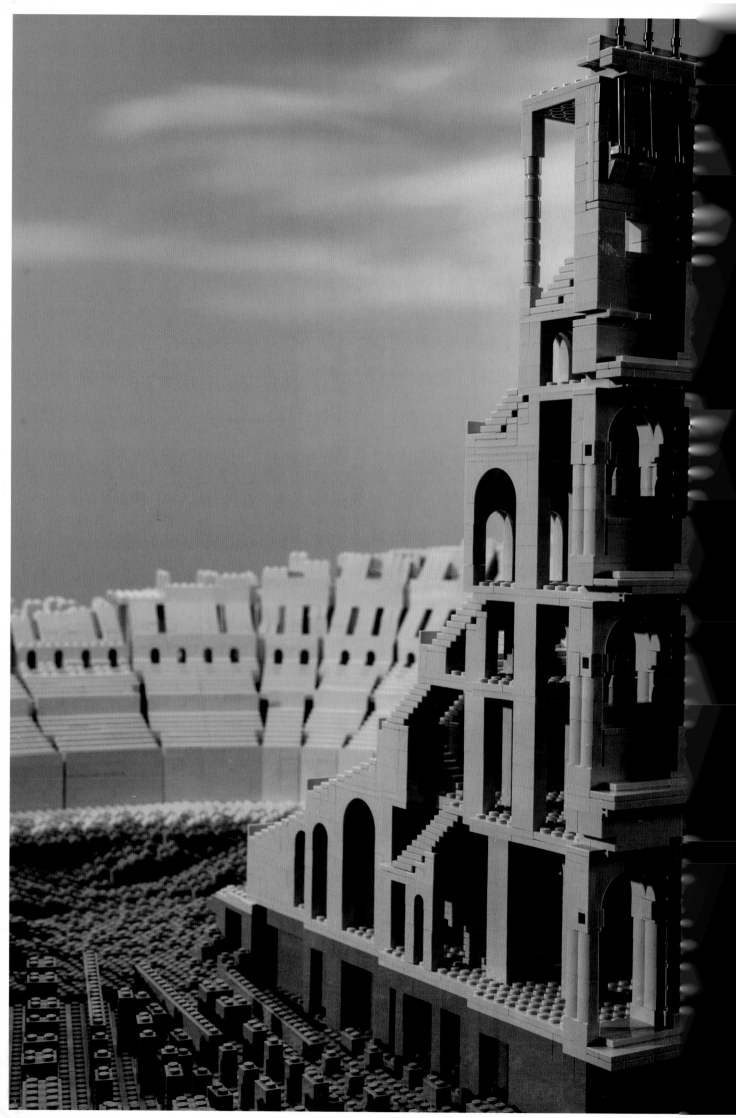

CONTENTS

Look for this symbol to find out how many bricks were used in each build.

GREATEST BRICK BUILDS VISUAL GUIDE

 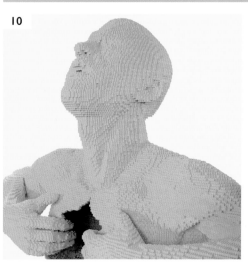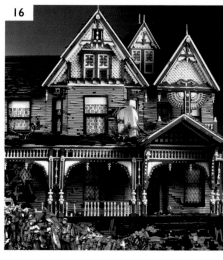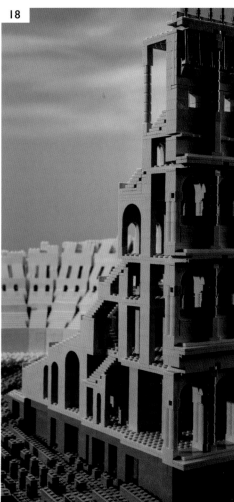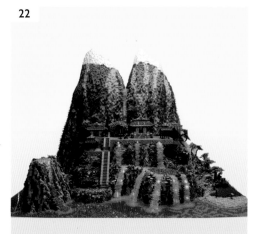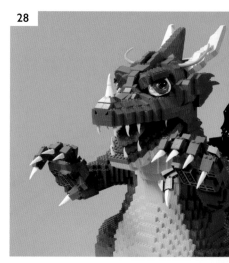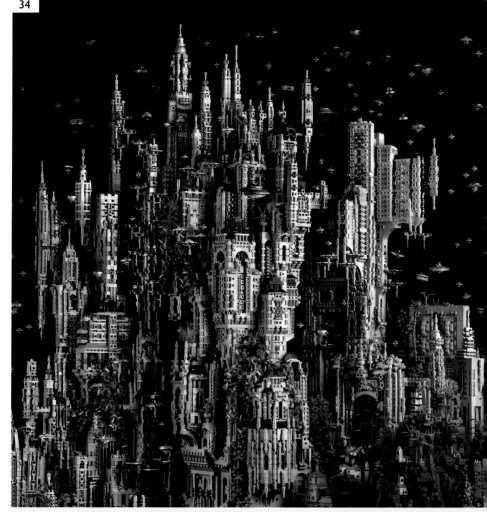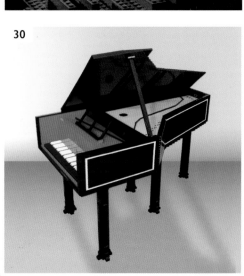

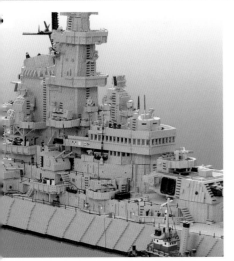

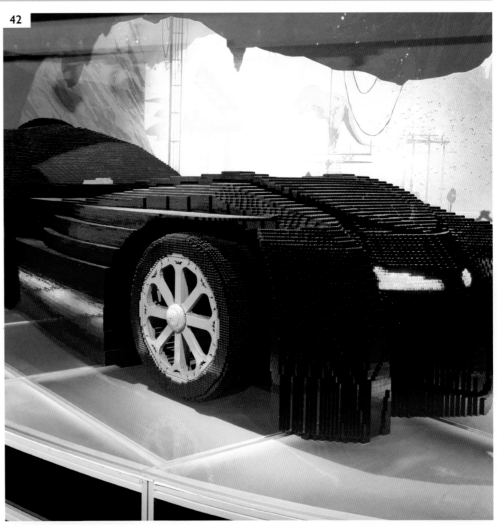

42

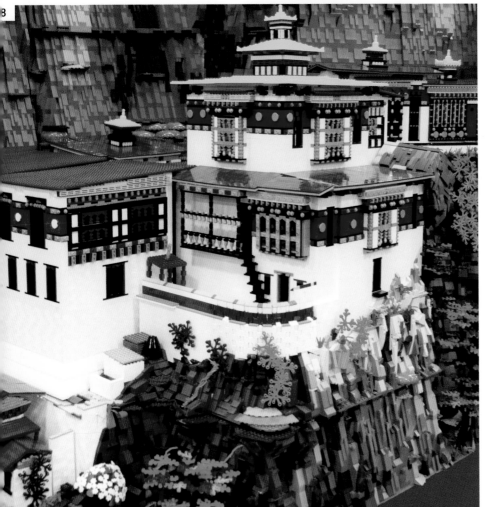

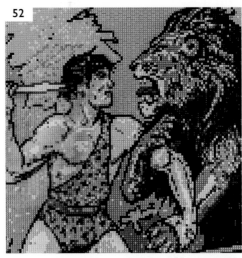

52

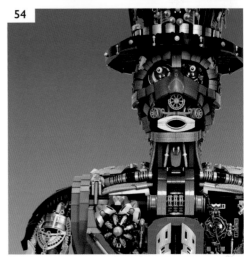

54

58

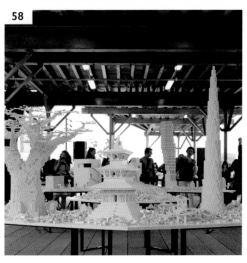

60

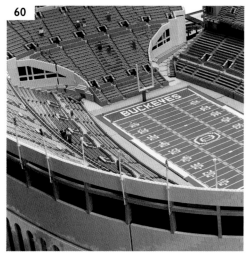

62

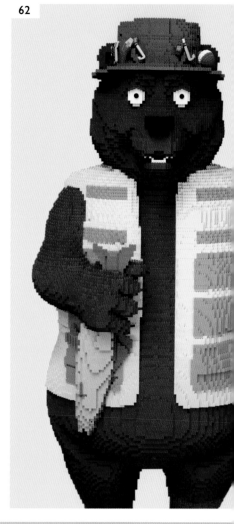

66

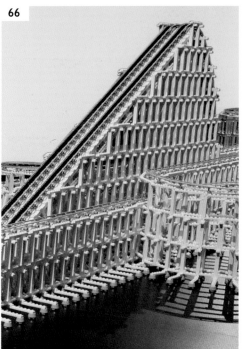

70

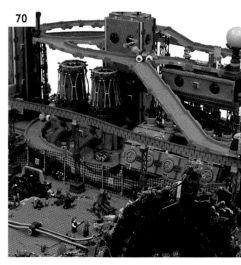

72

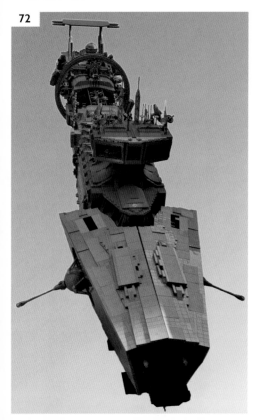

78

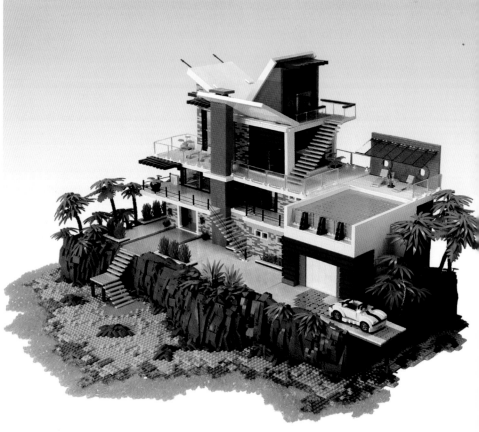

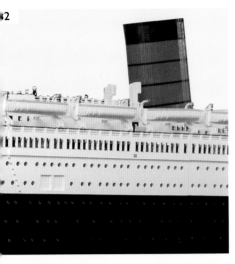

86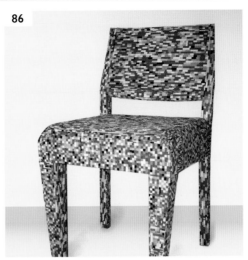

88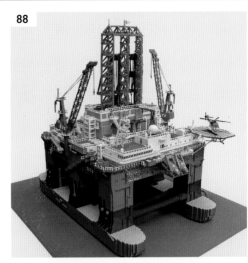

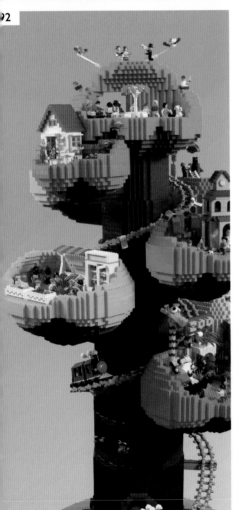

94

96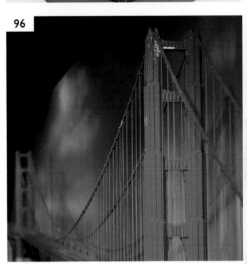

106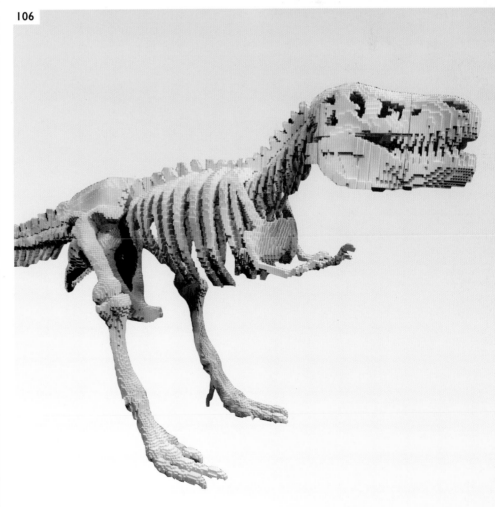

02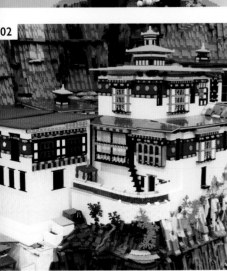

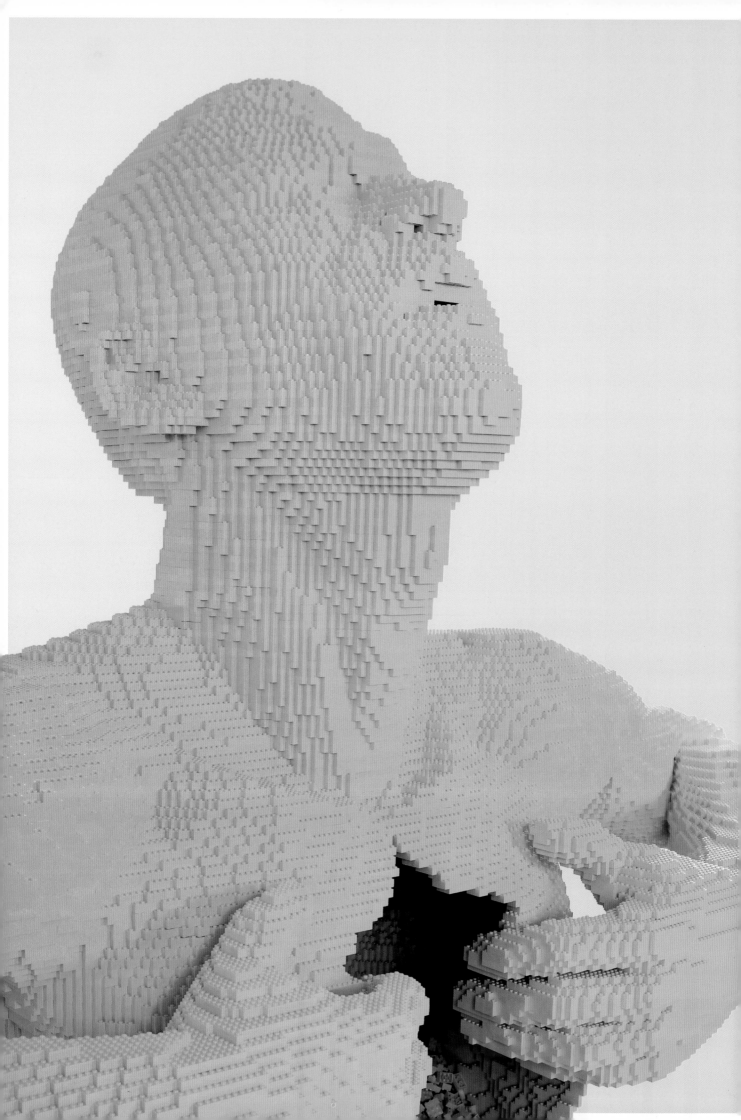

INTRODUCTION

It is such an honor to be asked to write the introduction to this book, as it showcases some of the most amazing creations ever made out of LEGO® bricks. These creations have been selected because they were made by some of the most talented artists and builders from around the world and reveal just how and why LEGO bricks are an amazing art medium.

I am a LEGO artist and I create artwork and sculptures (really big sculptures!) out of nothing but LEGO bricks, but you can build almost anything you like. In this book you will find architectural builds, vehicles, mosaics, sculptures, fine-art installations, and even a working harpsichord—made with LEGO. If you can think it, you can probably find a way to build it!

I got my first set of LEGO bricks when I was five years old. My parents always encouraged creativity and there were always things we could use to draw or sculpt with: Play-Doh®, Shrinky Dinks®, crayons, and of course, LEGO bricks.

My parents were also very accommodating—more than most parents would probably be. In fact, they let me build a 36 square foot LEGO city in our house, right behind the couch in the living room. It made for a solid conversation piece when the neighbors stopped by, but the thing about my city is that I built it by following the instructions, step-by-step, meticulously putting each brick exactly where the instruction booklet told me to put it.

That changed when I turned 10 years old. I wanted a dog, but I was told "no." So what did I do? I tore down a couple of buildings in my LEGO city, and I built my very own life-sized LEGO dog. I took those bricks and built something that I *wanted* to build, rather than recreating what was on the front of the box.

At that moment, I realized I could do whatever I wanted. The choice was mine. If I wanted to go to the moon, I could tear down another building and build myself a rocket ship; if I wanted to be a rock star, I'd tear down another building and build myself a guitar. There were no limits: LEGO bricks enabled me to explore my imagination and I didn't have to follow the instructions! That creative freedom made me happy.

Who would have thought that years later that creative child would have grown into a corporate attorney? I spent most of my days in sharply tailored suits sitting in boardrooms hashing out very important contracts. But I wasn't happy. Actually, that's not strong enough: I was *beyond miserable*.

After my days at the law office, I'd go home and need some sort of creative outlet. At first it was drawing, sometimes it was painting, and occasionally it was sculpting out of traditional media such as clay and wire. Then one day I thought about that toy from my childhood. Could I create legitimate works of art using LEGO bricks? It turned out I could!

So, I would spend my days negotiating deals in a boardroom, then go home to my apartment and crawl around on the floor—still in my suit—snapping bricks together. My New York apartment started to fill up with LEGO sculptures, but more surprising was that people were starting to buy them and commission new pieces.

One day, I made the leap: I walked into my boss's office on the 42nd floor of the Met Life Building and announced I was done. I was embarking on a ridiculous adventure: to be the first person to take LEGO into the art world.

People often ask me why I chose LEGO bricks as my art medium. The simple answer is that I wanted to be able to create artwork that was easily accessible. Everyone has snapped a few LEGO bricks together at some point, so it made my artwork more relatable and *inspirational*.

As an artist, my role is to inspire others—just like this book—and that is one of the most important tips I can share. Find your inspiration and just start building. If it doesn't look quite right, take it apart and try again; there is no right or wrong way to do it. Build whatever your heart tells you to—create anything you can see; piece together the things you imagine. Make your own mark and remember: you *don't* have to follow the instructions!

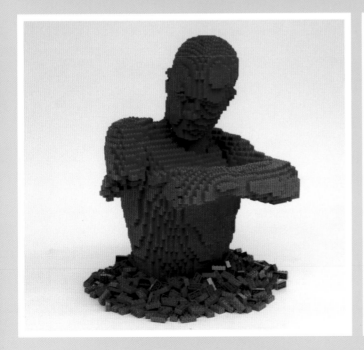

BIG YELLOW

Nathan Sawaya's original **Yellow** *sculpture is an iconic* **LEGO®** *build that received plenty of plaudits when it appeared in the artist's* **The Art of the Brick®** *exhibition.*

For many people, *Yellow* was the first time that they saw the simple plastic LEGO brick elevated from a child's plaything into a bona fide artist's medium, worthy of exhibiting in a gallery. In Sawaya's seminal sculpture from 2006, a life-size human figure appeared to tear open his chest, revealing himself fully to the world. Now, more than ten years on, Sawaya has revisited the theme and produced *Big Yellow*.

"Big" is certainly the operative word here, as the new build has a torso that stands almost 7 feet tall compared to the near-3-foot torso of its predecessor. Consequently, every detail of the human figure needed to be amplified beyond "life size" and this was not as straightforward as expected. There were several occasions when the look of the bricks was simply not working and Sawaya needed to chisel apart sections of the model that had already been glued. It was also difficult to work out how many bricks would be needed to fill the chest cavity: in the end almost 50,000 loose bricks were required to represent the figure's soul spilling out, taking the build's total brick count to well over 200,000.

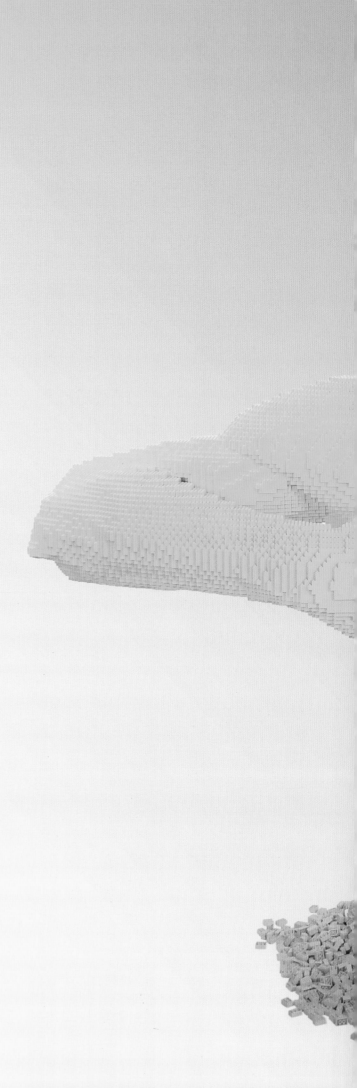

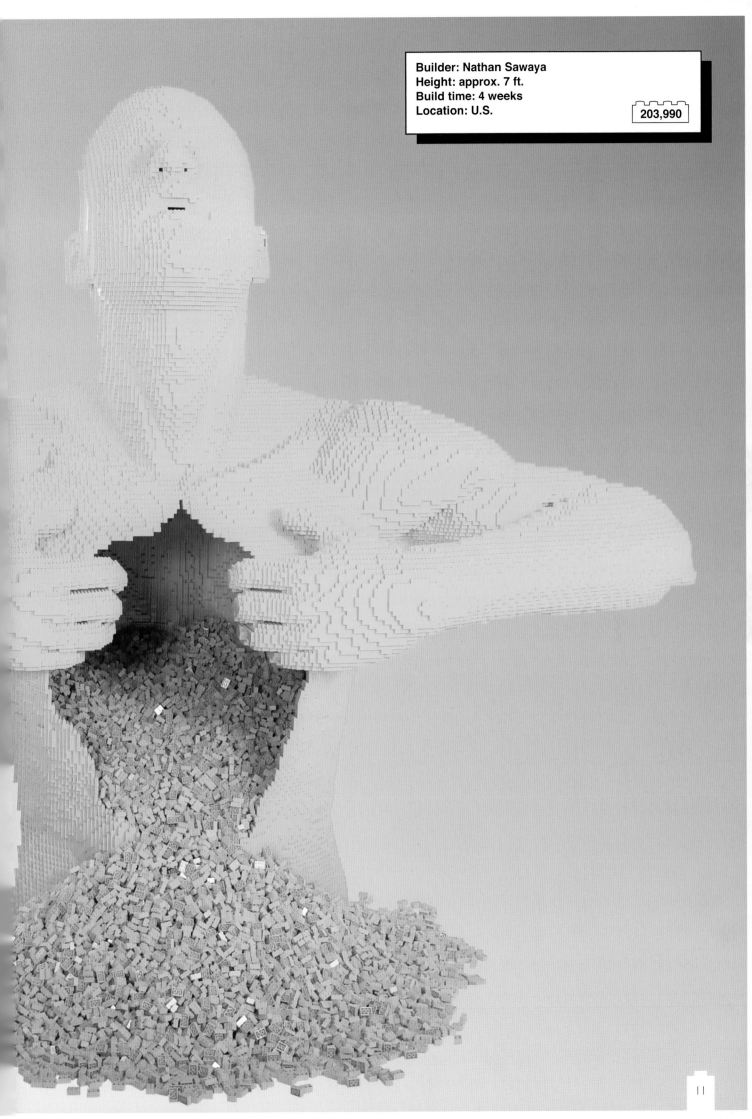

Builder: Nathan Sawaya
Height: approx. 7 ft.
Build time: 4 weeks
Location: U.S.

203,990

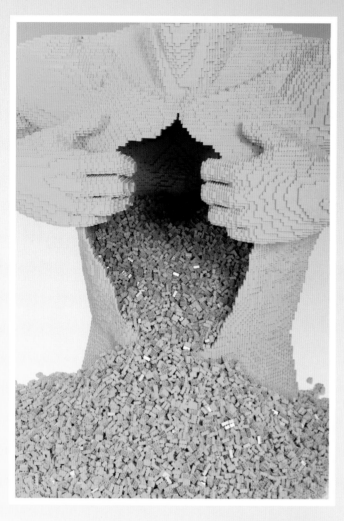

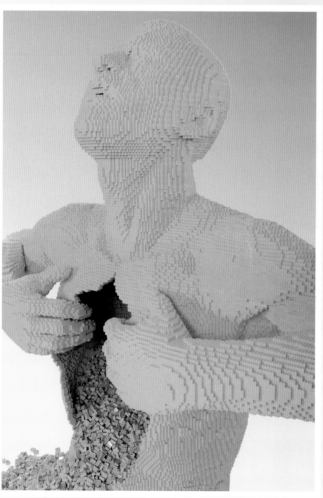

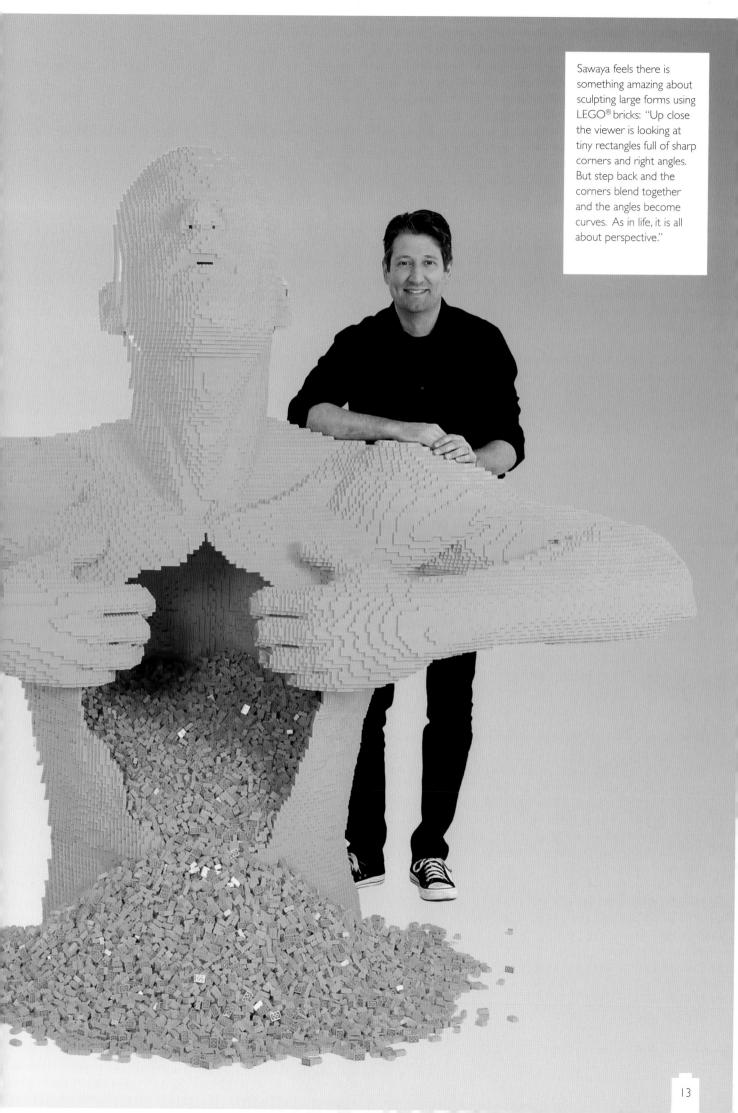

Sawaya feels there is something amazing about sculpting large forms using LEGO® bricks: "Up close the viewer is looking at tiny rectangles full of sharp corners and right angles. But step back and the corners blend together and the angles become curves. As in life, it is all about perspective."

HALIFAX DISCOVERY CENTER MOSAIC

When an experiential science center in Halifax, Canada, wanted to raise funds, the country's only LEGO® Certified Professional was more than happy to help.

The "Brickmaster" in question was Robin Sather, the founder of Brickville DesignWorks, which can be found just outside Vancouver on Canada's west coast. For this commission, Sather teamed up with a local silk artist, Holly Carr (pictured opposite), to design a mosaic for the center. The idea was that the duo's design would be broken down into small sections that the general public could buy (in the form of LEGO pieces) and then assemble, before fitting their small piece to the larger mosaic.

In total, 8,192 small sections were needed, which came together over a three-month period to create an impressive 20 foot by 10 foot mosaic containing more than 300,000 LEGO pieces. As of Spring 2017, Sather's work is the largest LEGO mosaic ever to have been constructed in Canada.

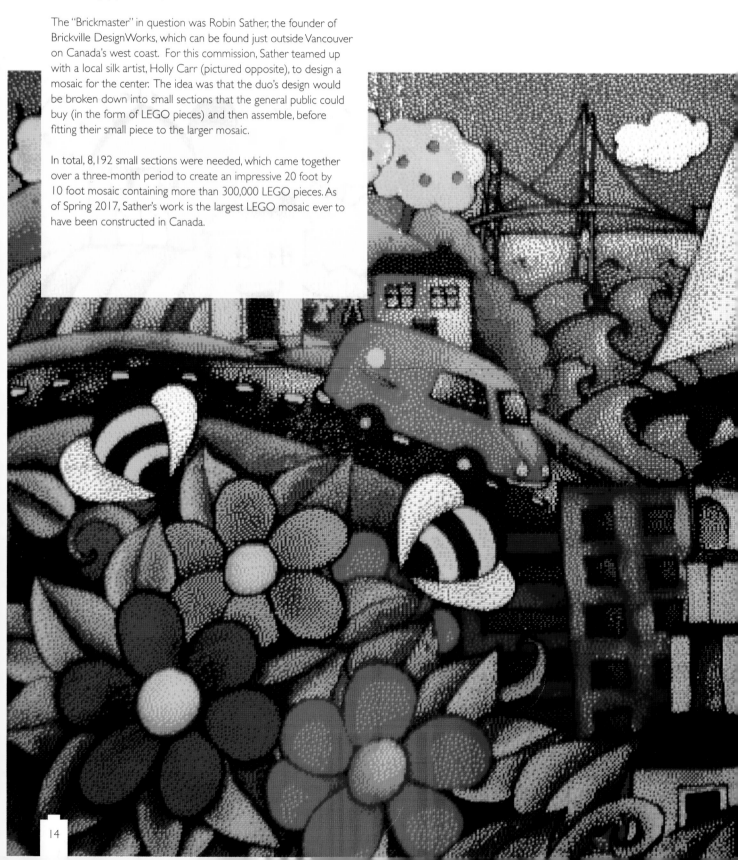

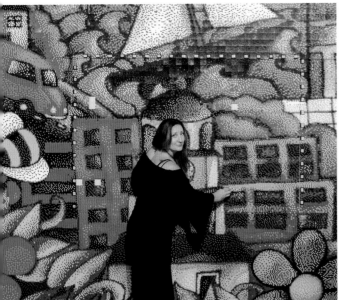

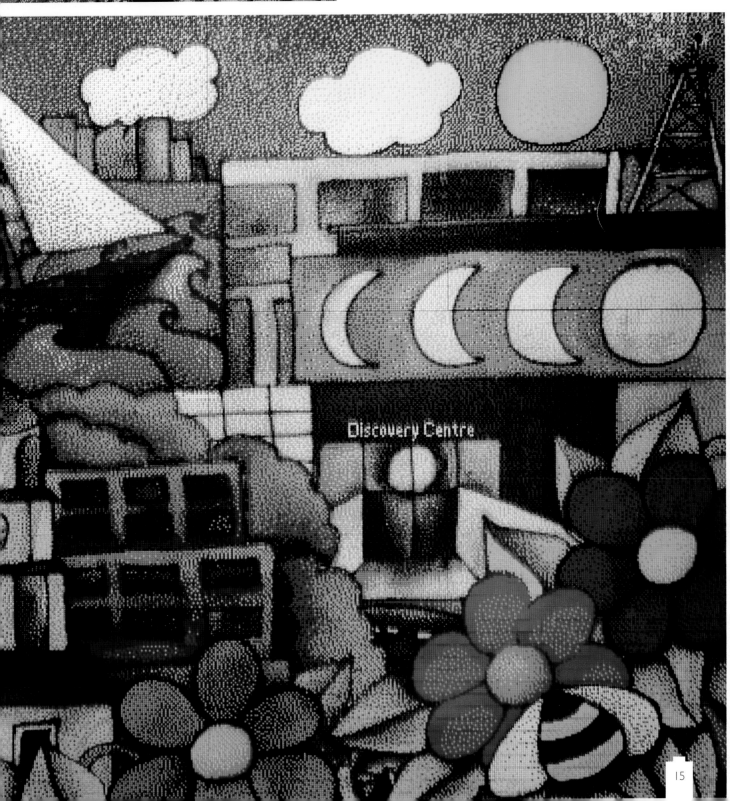

Builder: Robin Sather
Dimensions: 20 ft. x 10 ft.
Build time: approx. 3 months
Location: Canada

303,232

Discovery Centre

VICTORIAN HEAP

When Mike Doyle was looking to build the third model in his monochromatic Abandoned House series he intended to build a flooded building. However, while researching the model the Fukushima tsunami hit Japan.

Prompted by images of the aftermath of the Fukushima tragedy, Doyle decided to change the direction of his build. Rather than a flooded building, the house would sit on top of a giant mud heap littered with all sorts of debris (the refrigerator that has crashed into the second story was directly inspired by images of a boat that landed on top of a house).

It took Doyle more than 500 hours to complete the build, with the most challenging part being the construction of the "mud hill" that the house sits on. After exploring a number of options, the builder settled on a technique that used flexible LEGO® tubes anchored on the ground and running up to the foundation of the house. Doyle then attached plates to the tubes that could be angled in any direction and built up with other pieces to create the organic hill form. So, while it appears solid, the hill is just a shell—hollow on the inside, with a thin layer of suspended LEGO bricks creating the illusion that it's solid.

As with all of his builds, Doyle didn't glue his model, so once it had been photographed (and the photographs had been retouched) his *Victorian Heap* was dismantled and the monochrome pieces returned to their containers in preparation for the next model in the series—whatever that will be.

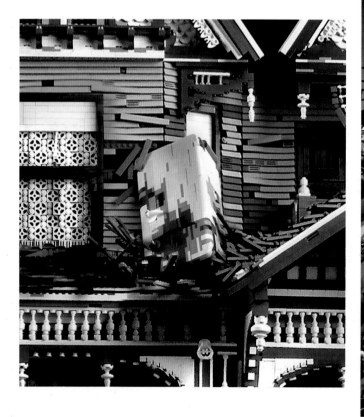

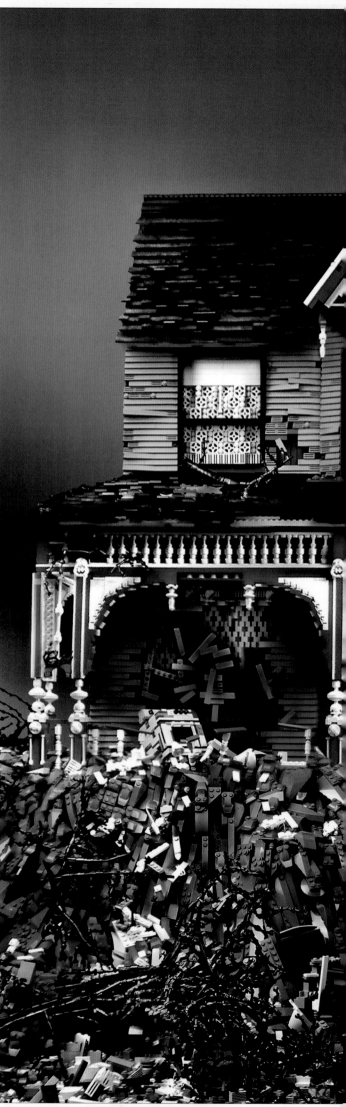

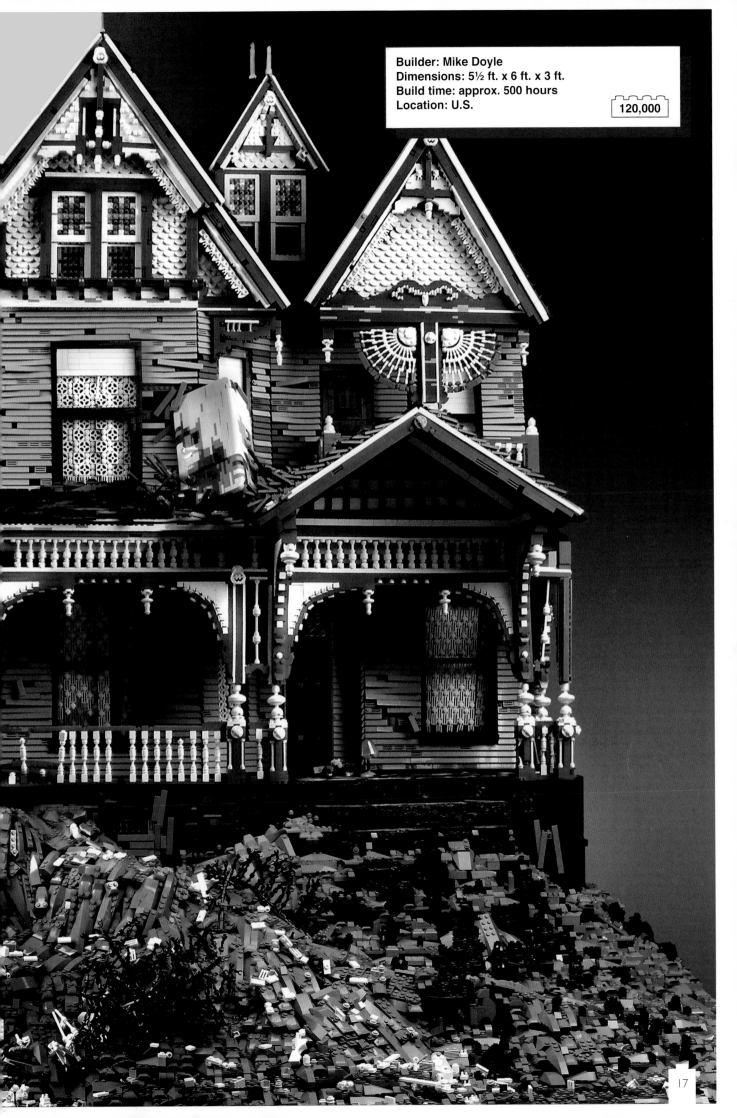

ROMAN COLOSSEUM

*As the creative force behind the LEGO®
Architecture range, Adam Reed Tucker is no
stranger to constructing realistic buildings on a
small scale. However, this was the first time that
he had stepped quite so far back into the past.*

Although it was the challenge of exploring the design and
construction of the famous Roman amphitheaters that initially
inspired the build, the ancient engineering methods also formed
an integral part of his model.

Rather than taking the most obvious path and simply recreating
an existing structure, Tucker instead chose to create a three-
dimensional "visual guide" to how these buildings are made. To
achieve this, the oval structure has been made in curved segments.
With each segment that is added, additional layers of detail begin
to appear. Starting at ground level, in the first segment, supporting
columns, floors, seating, and interiors all start to "grow" as your
eye travels clockwise around the segmented oval structure.

As the visual journey continues, these elements start to become
complete, until the very final segment, which reveals a perfect
cross section of the building. In this way, Tucker's model takes
the viewer from foundation to completion: providing the entire
anatomy of its construction through a 360-degree visual journey.

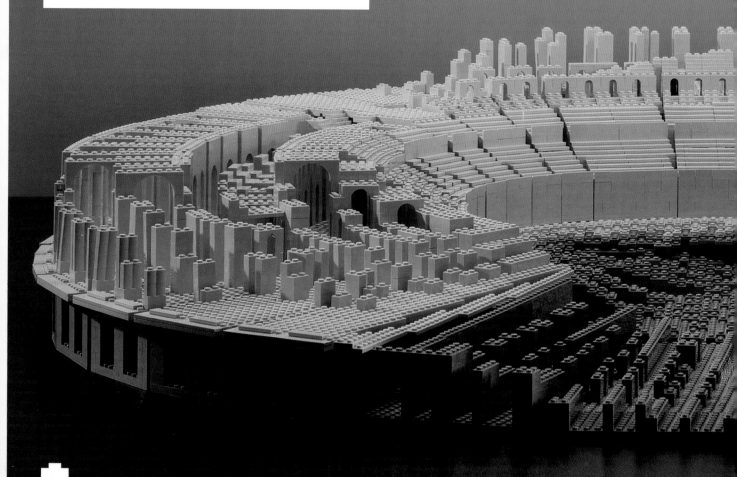

Builder: Adam Reed Tucker
Dimensions: 5 ft. x 3 ft. x 1½ ft.
Build time: 240 hours
Location: U.S.

35,000

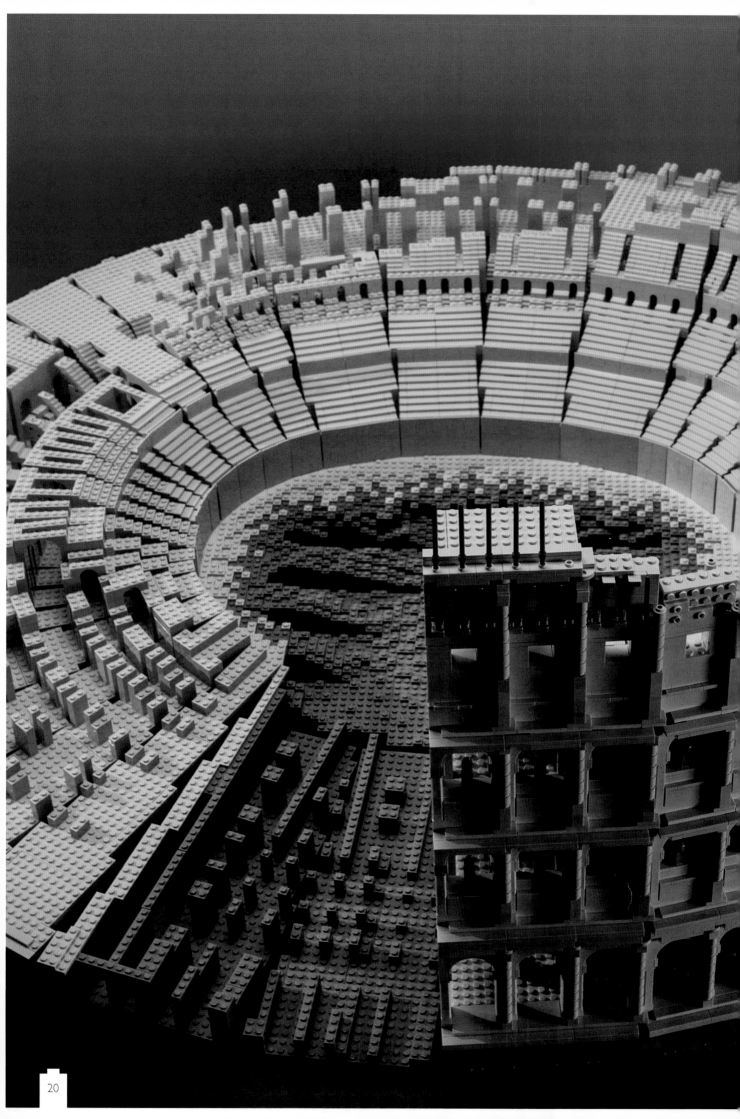

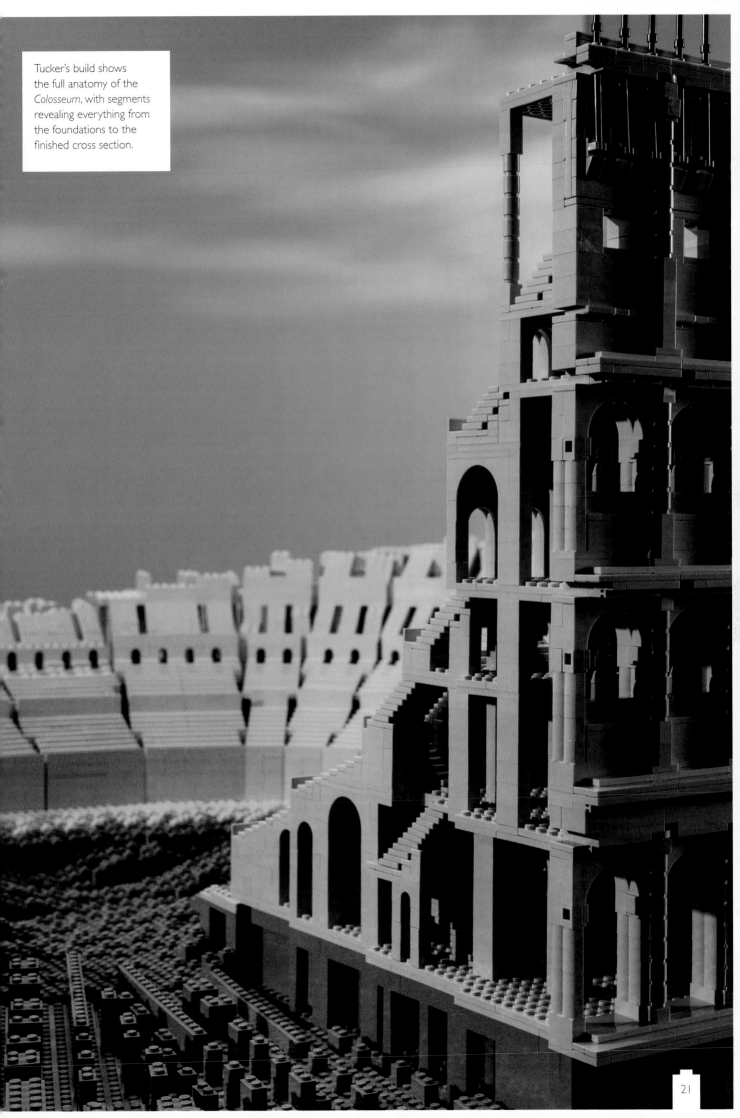

Tucker's build shows the full anatomy of the *Colosseum*, with segments revealing everything from the foundations to the finished cross section.

SAMURAI CODE

Ben Pitchford started his build with the aim of creating a Ninjago City for his son. However, this soon morphed into a much grander vision, based around a mountainside village in feudal Japan.

In his basement crammed with boxes and bags of LEGO® bricks, Pitchford built the samurai village over a nine-month period, painstakingly piecing together more than 100,000 bricks. The finished build consists of ten unglued sections that slide apart when Pitchford wants to transport the model and then come seamlessly back together again to form the mountainside diorama.

While Pitchford's build has won awards such as the "Best Individual Layout Award" at Brickworld Chicago 2016, at heart it remains true to its original premise: to provide his son with a setting to play with his Ninjago Minifigures. Consequently there are plenty of fun elements to the build, such as skeletal remains in hidden caves, motorized training weapons that can knock an unsuspecting Minifigure off its feet, and an optional zip line that can be used to make a rapid descent from the highest peak.

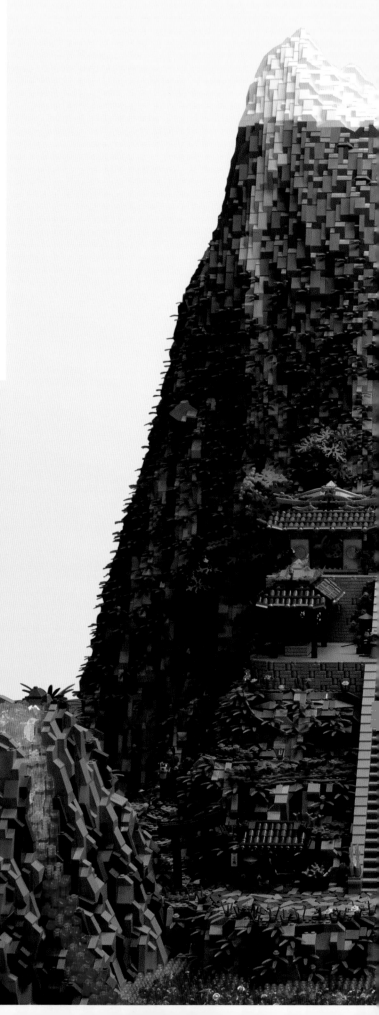

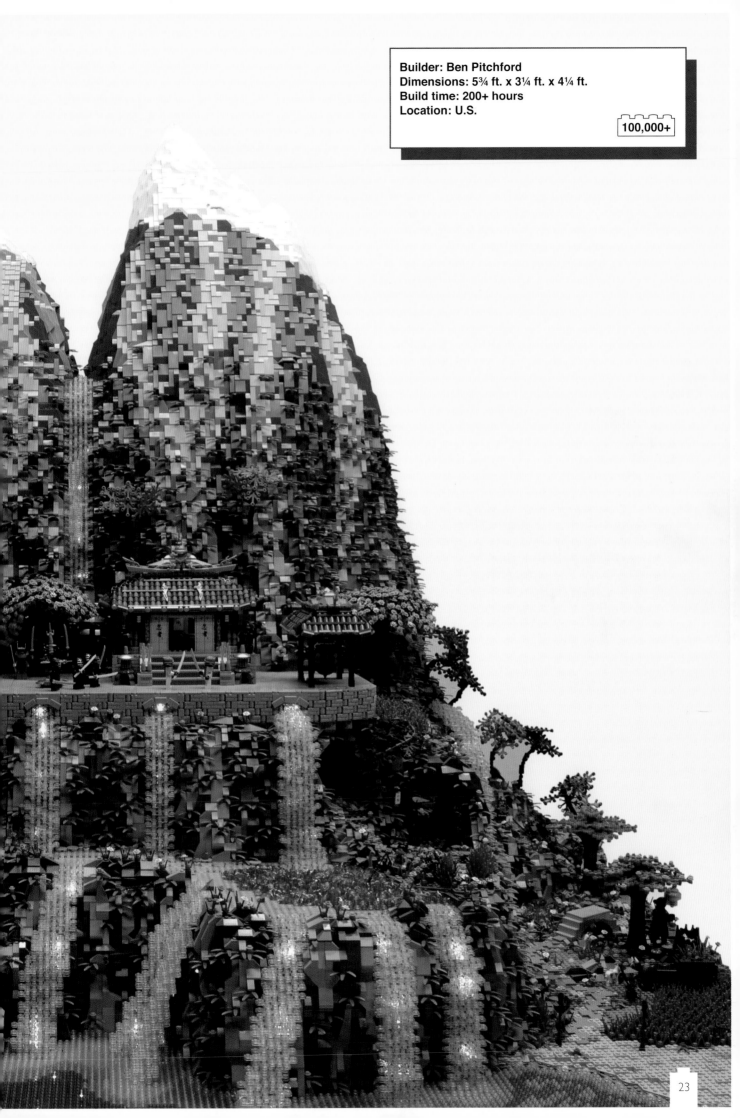

Builder: Ben Pitchford
Dimensions: 5¾ ft. x 3¼ ft. x 4¼ ft.
Build time: 200+ hours
Location: U.S.

100,000+

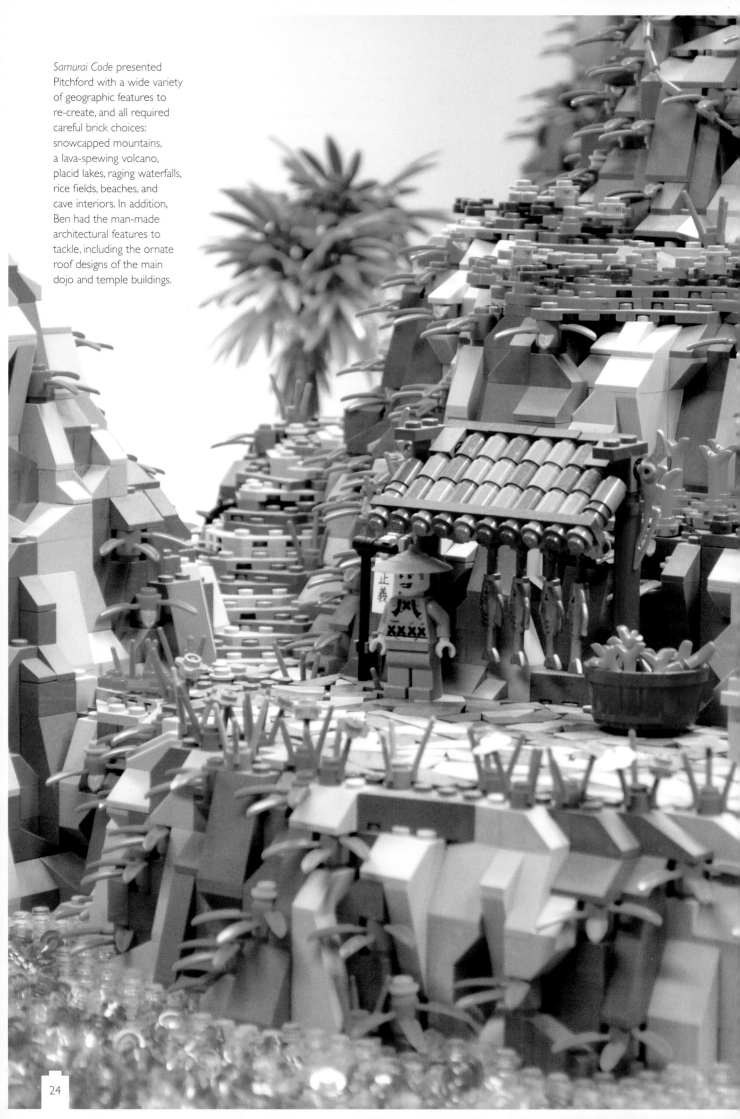

Samurai Code presented Pitchford with a wide variety of geographic features to re-create, and all required careful brick choices: snowcapped mountains, a lava-spewing volcano, placid lakes, raging waterfalls, rice fields, beaches, and cave interiors. In addition, Ben had the man-made architectural features to tackle, including the ornate roof designs of the main dojo and temple buildings.

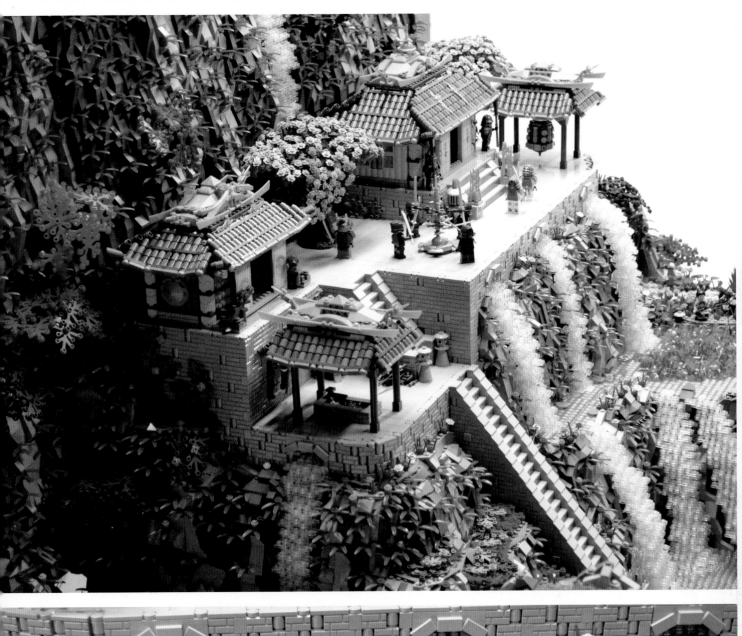

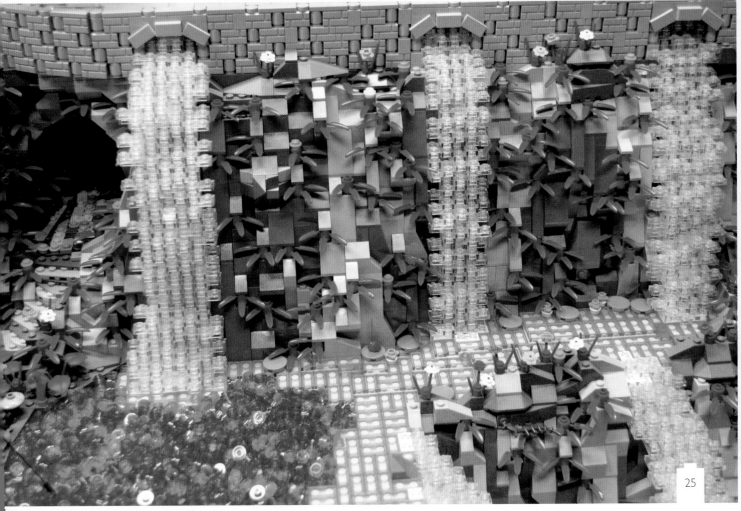

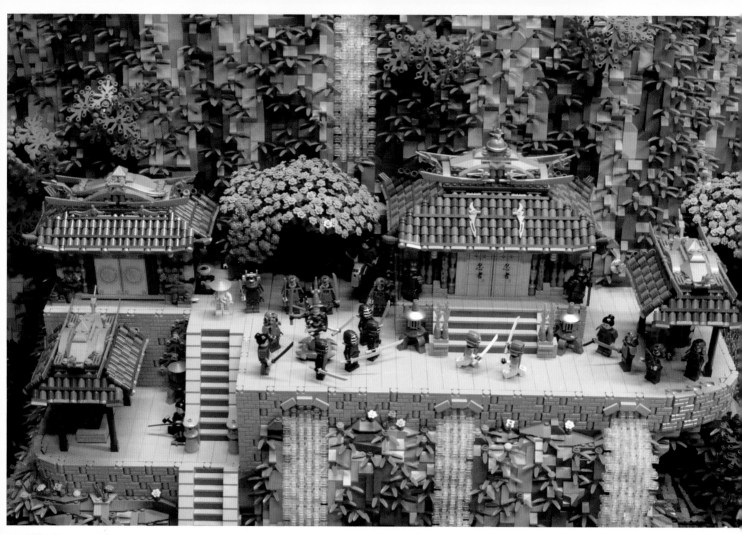

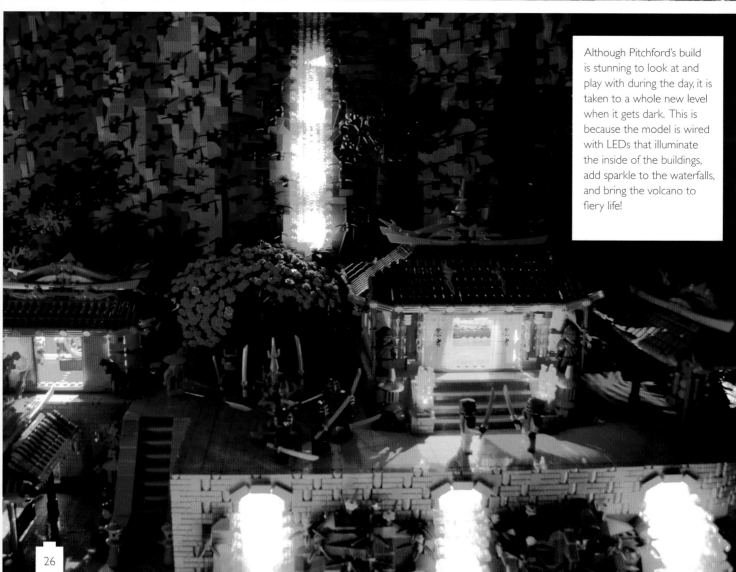

Although Pitchford's build is stunning to look at and play with during the day, it is taken to a whole new level when it gets dark. This is because the model is wired with LEDs that illuminate the inside of the buildings, add sparkle to the waterfalls, and bring the volcano to fiery life!

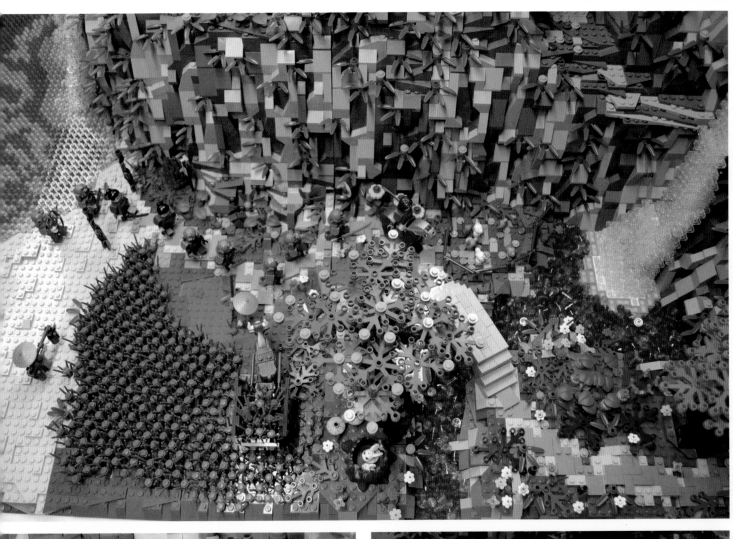

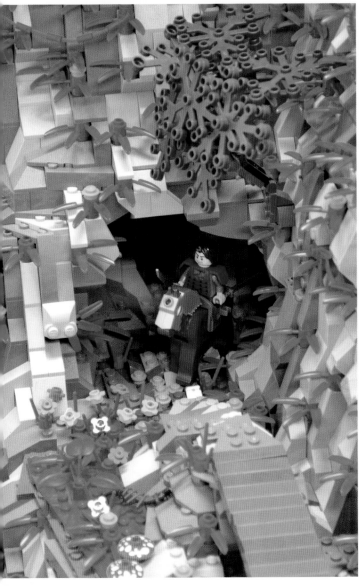

GREEN DRAGON

When Sachiko Akinaga needed to build a creature for a Japanese television show, a green dragon that combined "power" with "kawaii" (cute) was the thing that sprang to mind.

The immediate challenge for the freelance graphic designer and LEGO® artist was that she hadn't made anything like this before and was working to a really tight schedule. Although she was worried she was trying to do too much in the time she had available, devoting seventy intense hours to the project over a seven-day period saw Akinaga's dragon assembled using more than 18,000 LEGO bricks.

On its own, this would have been a major accomplishment, but Akinaga wanted her dragon to be more than just a static model. To add some movement, a pair of pneumatic cylinders was attached at the back: when air is pushed into the cylinders, hydraulic rods extend out and push the wings forward; when the air is pulled from the cylinders, the wings move backward. In this way, the dragon's wings can be made to flap, bringing Akinaga's fiercely cute *Green Dragon* to life!

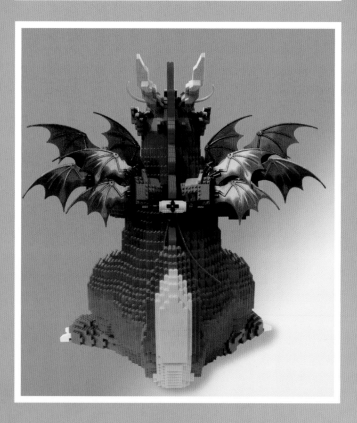

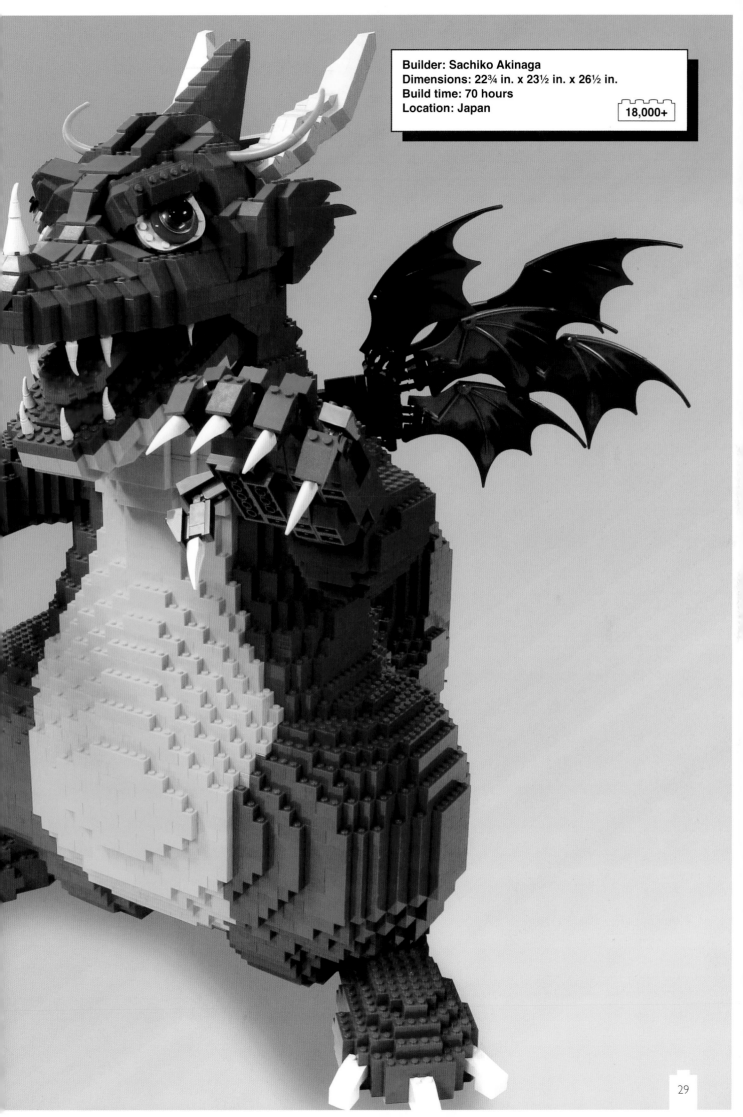

Builder: Sachiko Akinaga
Dimensions: 22¾ in. x 23½ in. x 26½ in.
Build time: 70 hours
Location: Japan

18,000+

LEGO®
HARPSICHORD

As a musician and LEGO builder, it was perhaps inevitable that Henry Lim would want to combine his passions and create a playable musical instrument out of bricks.

The first issue to overcome was the choice of instrument. As a pianist, the piano was Lim's immediate choice, but the tension in the strings meant it was impossible: as Lim says, "There's a reason why pianos have frames made of steel!" As an alternative, Lim opted for the piano's predecessor—the harpsichord.

Two years in the making, Lim's project was far from an "instant fix." Extensive theorizing, designing, and parts collection was followed by building, testing, and rebuilding as Lim "tuned" his instrument. There were numerous problems that needed to be solved along the way, but the biggest challenge was making sure that the tension of the strings could be maintained: "For every string I attached, exponentially, I was afraid the model was going to implode."

Lim made his instrument as smooth as possible by covering the LEGO® studs with smooth tiles. Even the (unseen) floor of the soundchamber is decked with hundreds of tiles to make it as resonant as it can be.

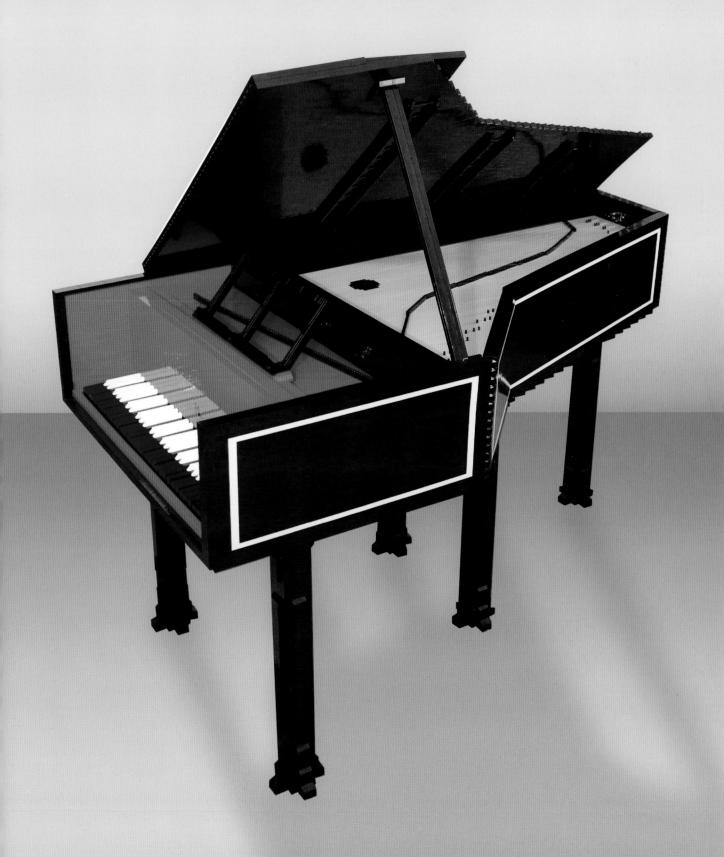

Builder: Henry Lim
Dimensions: 6 ft. x 3 ft. x 5 ft. (with lid open)
Build time: 2 years
Location: U.S.

100,000

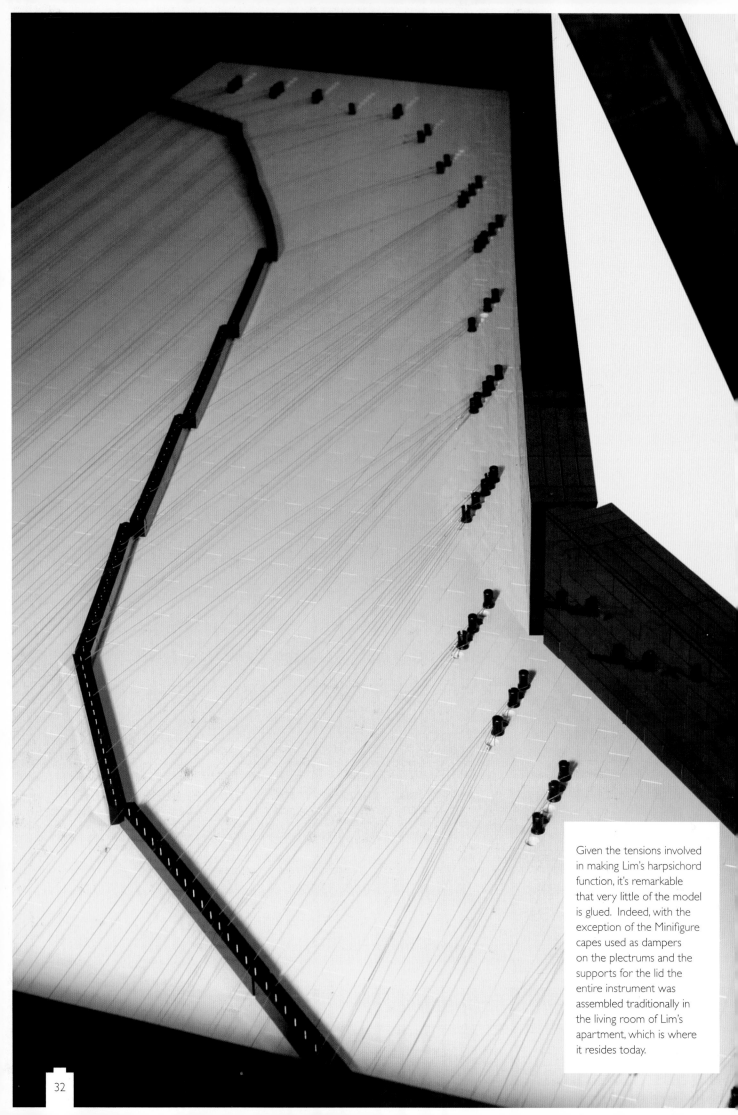

Given the tensions involved in making Lim's harpsichord function, it's remarkable that very little of the model is glued. Indeed, with the exception of the Minifigure capes used as dampers on the plectrums and the supports for the lid the entire instrument was assembled traditionally in the living room of Lim's apartment, which is where it resides today.

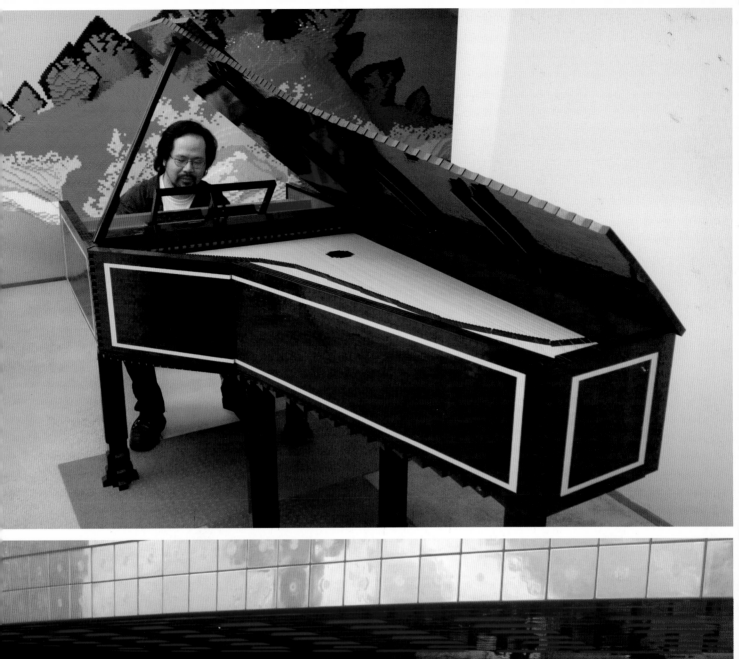

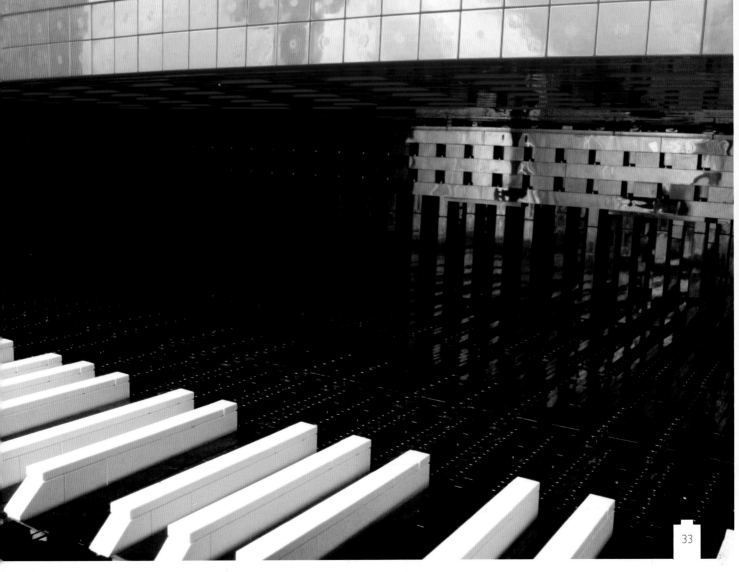

MILLENNIAL CELEBRATION

The Millennial Celebration of the Eternal Choir at K'al Yne, Odan *(to give it its full title)* is based on a story that Mike Doyle created around the themes of spirituality, near-death experience, UFOs, and meditation.

Over a period of eight months, Doyle spent about 600 hours meticulously assembling his micro-scale build, where one plate in the model equals one floor in the building. Remarkably, this is not only Doyle's first micro-scale build, but also the largest model he has ever made, thanks to its 6 foot by 5 foot footprint and towers that rise 5 feet into the air. This large scale was not entirely intentional, though, as the model seemingly took on a life of its own, growing way beyond the initial plans and putting its builder in "constant purchasing mode" as he needed more and more pieces.

Like many great builds, it was not without its challenges, and Doyle spent many hours working by flashlight after a hurricane knocked out his power for more than a week! However, his persistence paid off, and the result is a spectacular vision of an alternate world. Once the model was finished, Doyle photographed it—which is the ultimate goal for all his work—and then began the painstaking process of dismantling it, carefully filing the pieces back into the bin cabinets in his build space, ready for his next project.

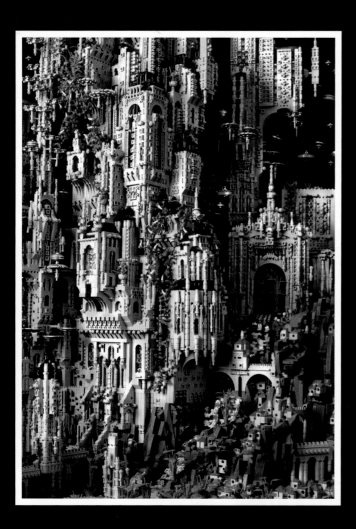

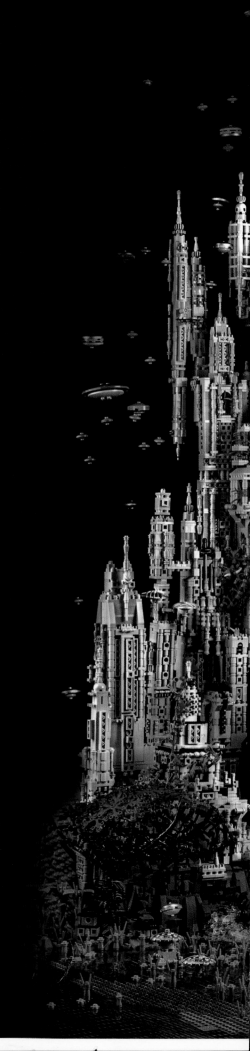

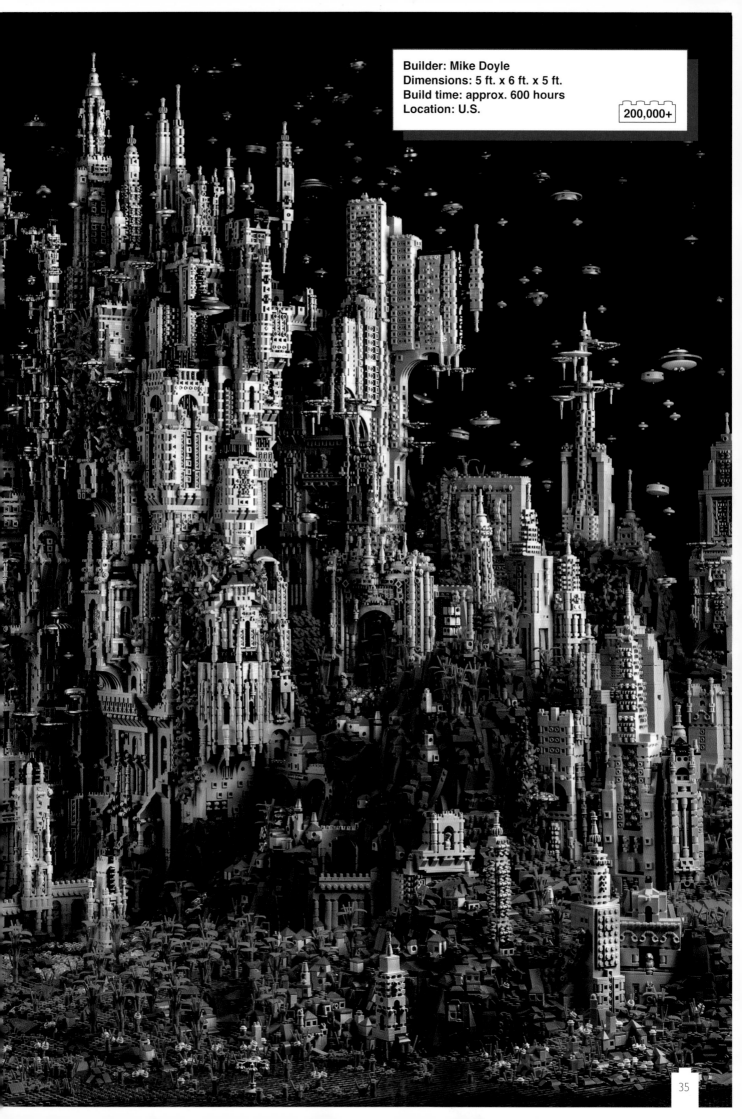

Builder: Mike Doyle
Dimensions: 5 ft. x 6 ft. x 5 ft.
Build time: approx. 600 hours
Location: U.S.

200,000+

USS MISSOURI ("MIGHTY MO")

As the son of a fisherman, boats run in Jim McDonough's blood, so it's perhaps unsurprising that ships are also the favorite subject for his LEGO® builds.

To date, McDonough has built more than twenty ships (and planes) at his home in Scotland. While many builders dismantle their projects when they move on to something new, each of McDonough's models stay in one piece, "docked" in his increasingly full garage. These aren't micro-scale builds either. His first "proper" ship was an 18-foot replica of the IJN *Fusō* (one of two Fusō-class battleships built for the Imperial Japanese Navy); he's completed a 17-foot model of the USS *Arizona*; and has numerous other ships at a similar scale.

However, at almost 25 feet in length, McDonough's biggest build to date (and his most recent) is the USS *Missouri*, or "Mighty Mo," scene of the Japanese surrender at the end of World War II. Built over a period of three years, McDonough lost count of the pieces used in its construction, but the deck swallowed up 20,000 bricks, and each of the main gun turrets weighs in at a hefty 7.7 pounds.

What is more remarkable, though, is that McDonough designs his ships as he builds them, working from reference photographs instead of using any LEGO design software to simplify the process. This not only makes it far more challenging to create modular builds that can be broken down for transporting, it also means that gluing his ships isn't an option—each brick needs to be "free" so he can build and rebuild until he ends up with the "perfect" new addition to his fleet.

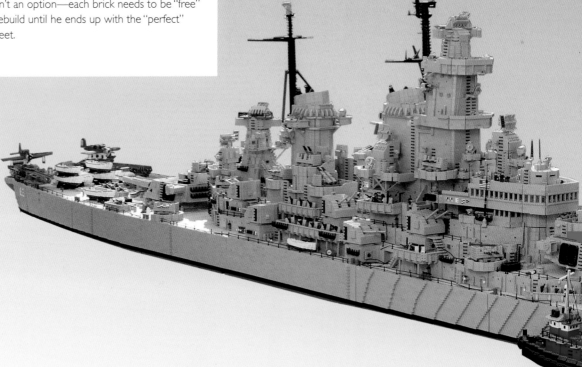

Builder: Jim McDonough
Length: 24¾ ft.
Build time: approx. 3 years
Location: Scotland

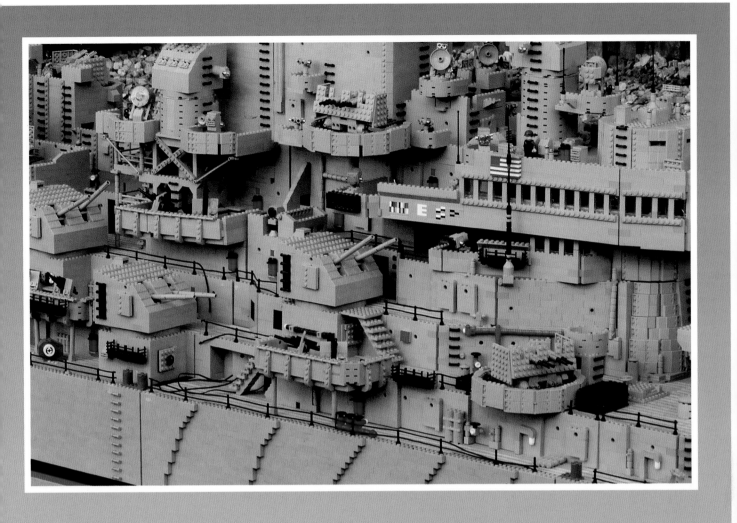

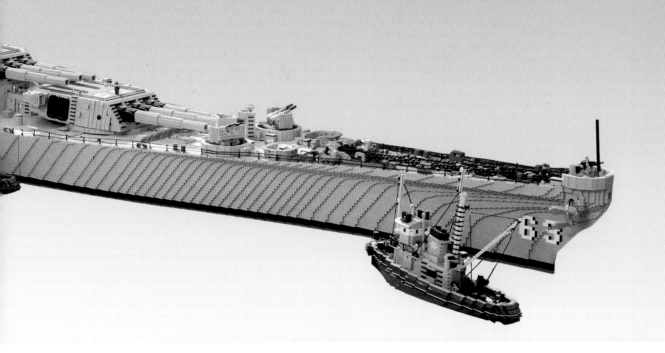

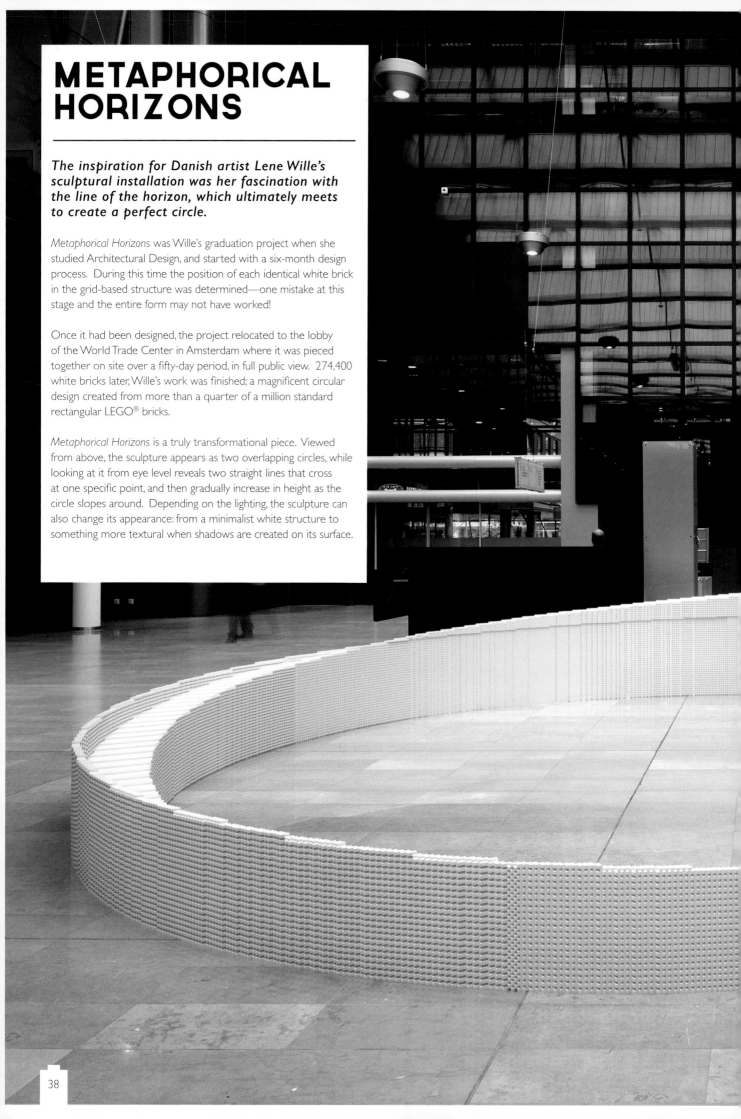

METAPHORICAL HORIZONS

The inspiration for Danish artist Lene Wille's sculptural installation was her fascination with the line of the horizon, which ultimately meets to create a perfect circle.

Metaphorical Horizons was Wille's graduation project when she studied Architectural Design, and started with a six-month design process. During this time the position of each identical white brick in the grid-based structure was determined—one mistake at this stage and the entire form may not have worked!

Once it had been designed, the project relocated to the lobby of the World Trade Center in Amsterdam where it was pieced together on site over a fifty-day period, in full public view. 274,400 white bricks later, Wille's work was finished; a magnificent circular design created from more than a quarter of a million standard rectangular LEGO® bricks.

Metaphorical Horizons is a truly transformational piece. Viewed from above, the sculpture appears as two overlapping circles, while looking at it from eye level reveals two straight lines that cross at one specific point, and then gradually increase in height as the circle slopes around. Depending on the lighting, the sculpture can also change its appearance: from a minimalist white structure to something more textural when shadows are created on its surface.

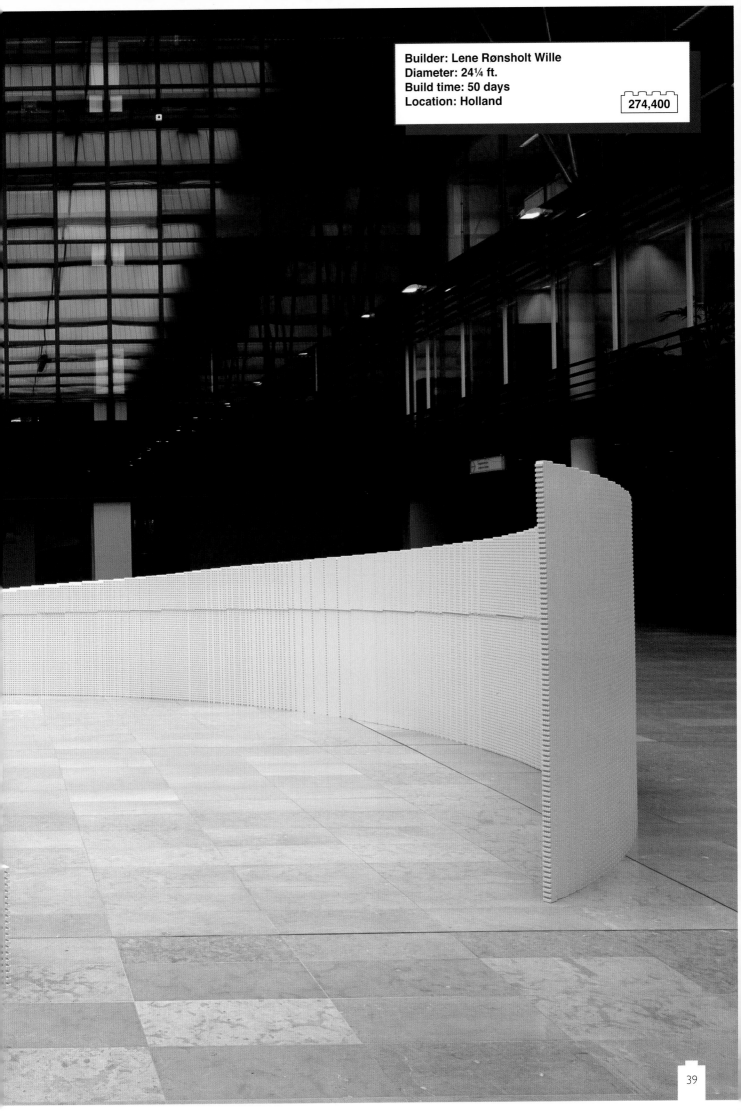

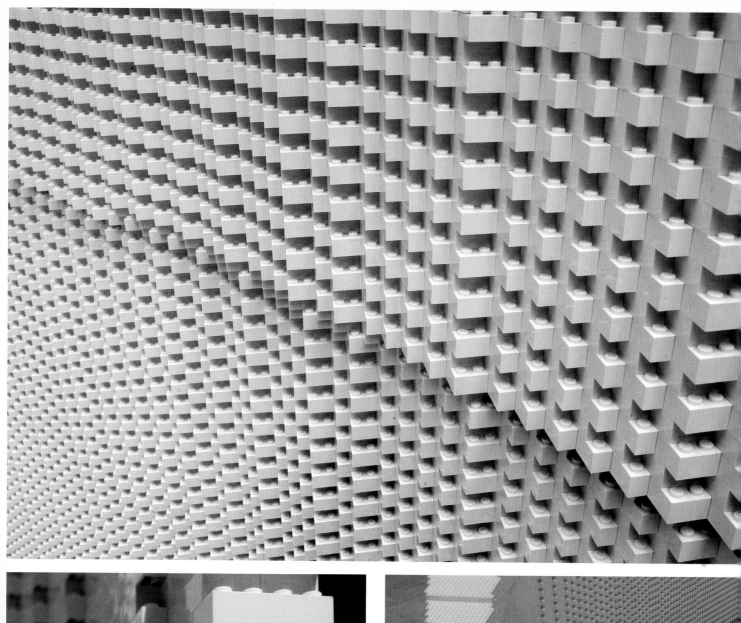

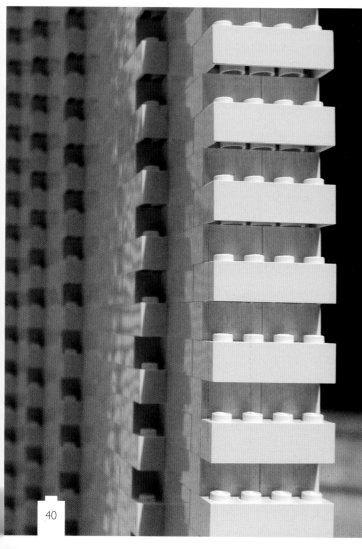

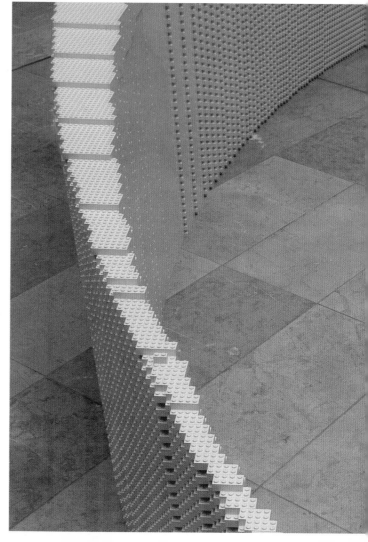

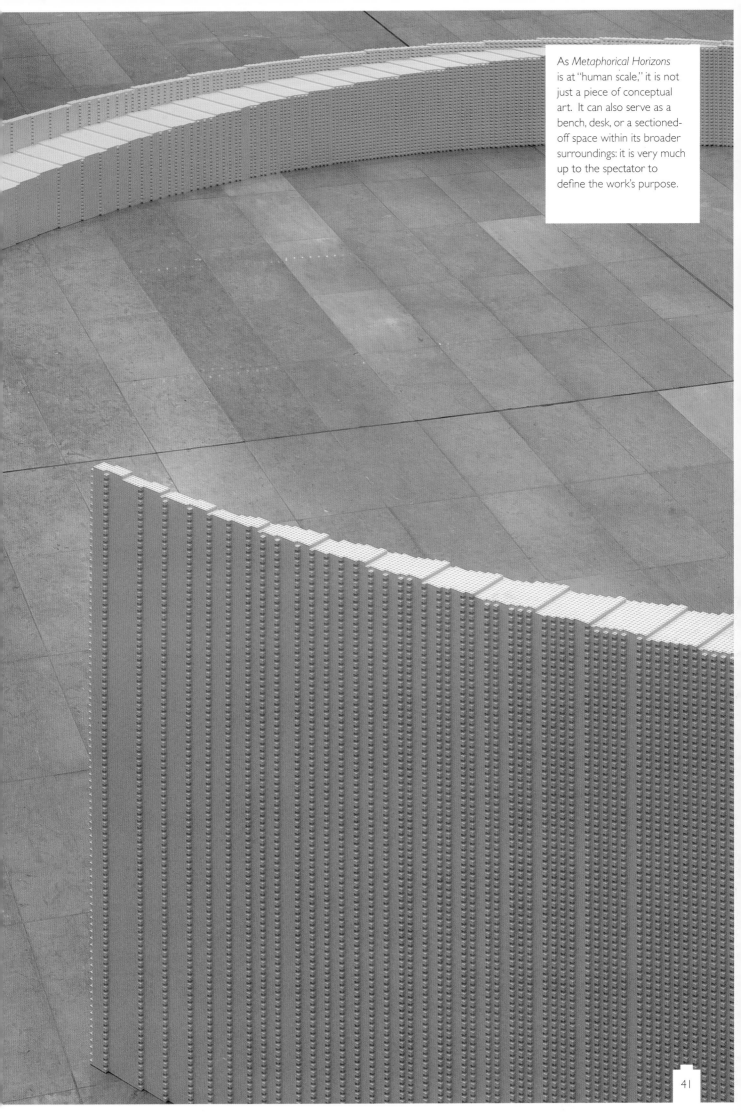

As *Metaphorical Horizons* is at "human scale," it is not just a piece of conceptual art. It can also serve as a bench, desk, or a sectioned-off space within its broader surroundings: it is very much up to the spectator to define the work's purpose.

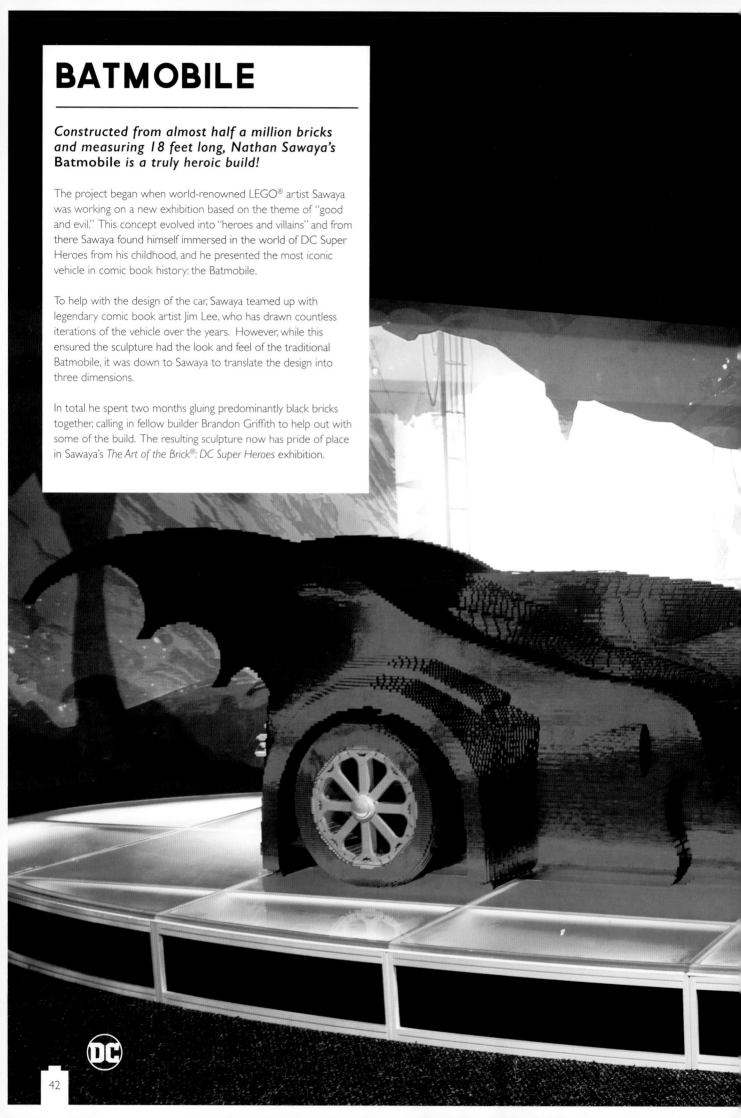

BATMOBILE

Constructed from almost half a million bricks and measuring 18 feet long, Nathan Sawaya's **Batmobile** *is a truly heroic build!*

The project began when world-renowned LEGO® artist Sawaya was working on a new exhibition based on the theme of "good and evil." This concept evolved into "heroes and villains" and from there Sawaya found himself immersed in the world of DC Super Heroes from his childhood, and he presented the most iconic vehicle in comic book history: the Batmobile.

To help with the design of the car, Sawaya teamed up with legendary comic book artist Jim Lee, who has drawn countless iterations of the vehicle over the years. However, while this ensured the sculpture had the look and feel of the traditional Batmobile, it was down to Sawaya to translate the design into three dimensions.

In total he spent two months gluing predominantly black bricks together, calling in fellow builder Brandon Griffith to help out with some of the build. The resulting sculpture now has pride of place in Sawaya's *The Art of the Brick®: DC Super Heroes* exhibition.

Builder: Nathan Sawaya
Length: 18 ft.
Build time: 2 months
Location: U.S.

489,012

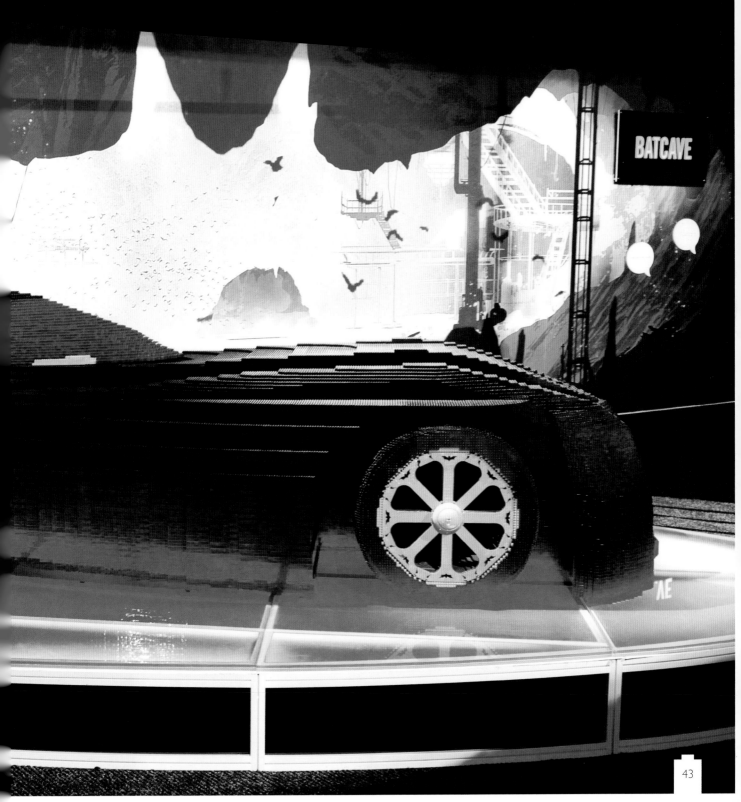

BATCAVE

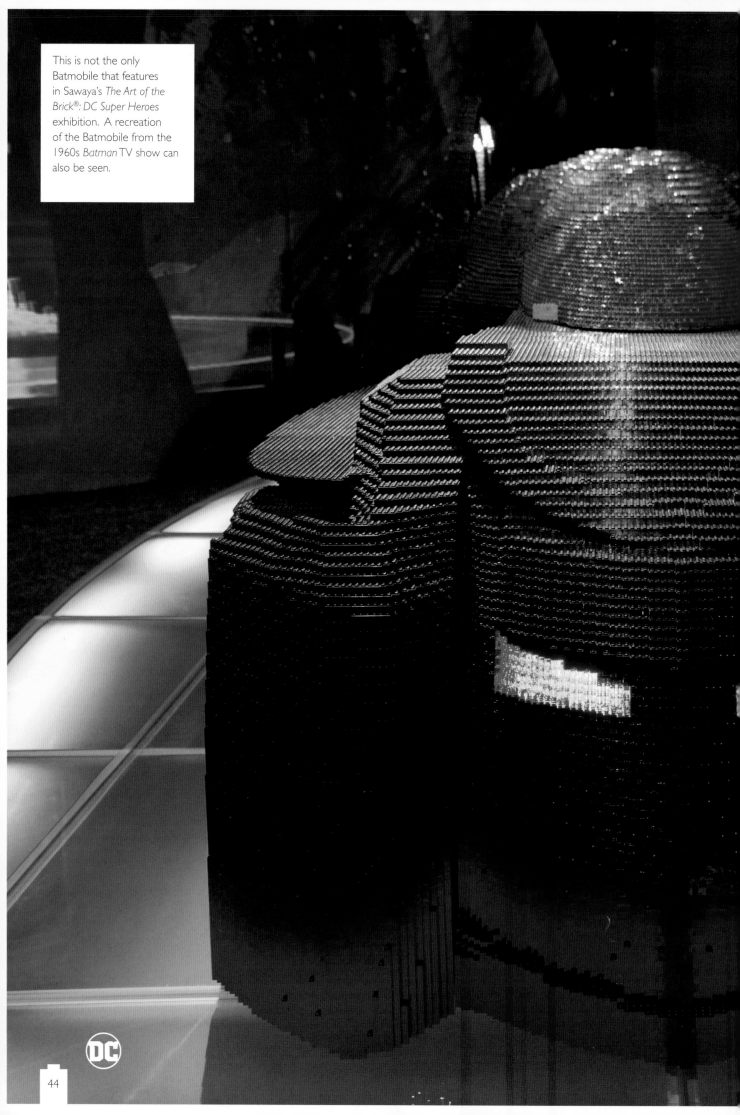

This is not the only Batmobile that features in Sawaya's *The Art of the Brick®: DC Super Heroes* exhibition. A recreation of the Batmobile from the 1960s *Batman* TV show can also be seen.

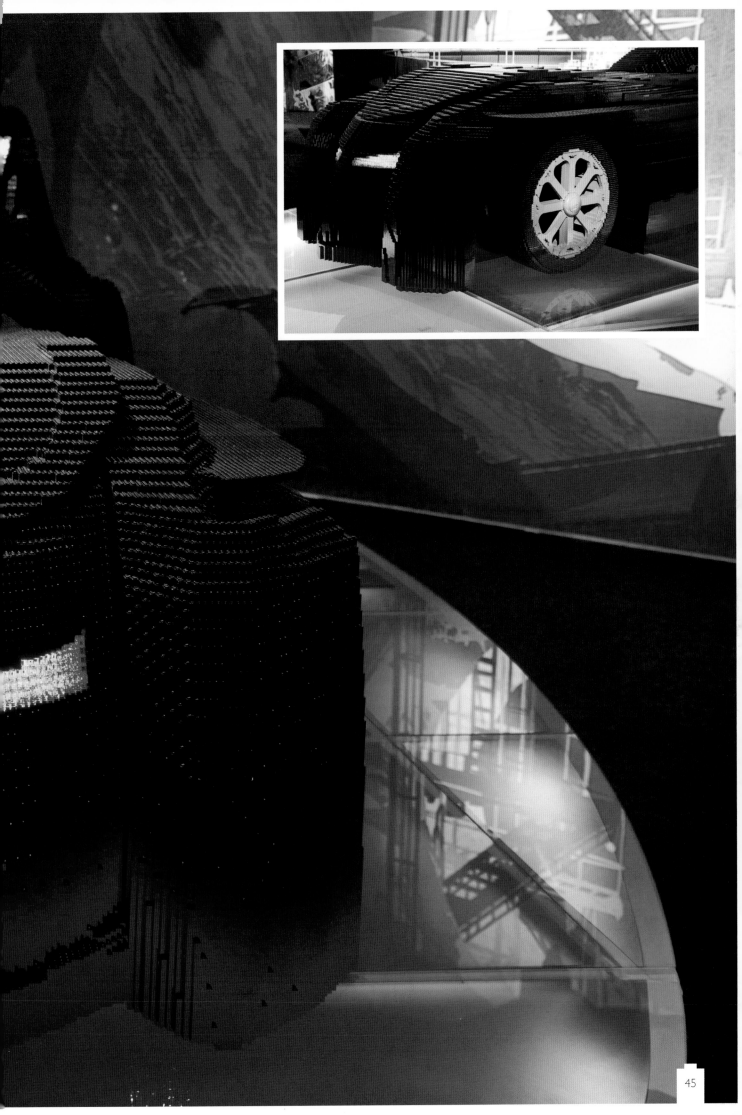

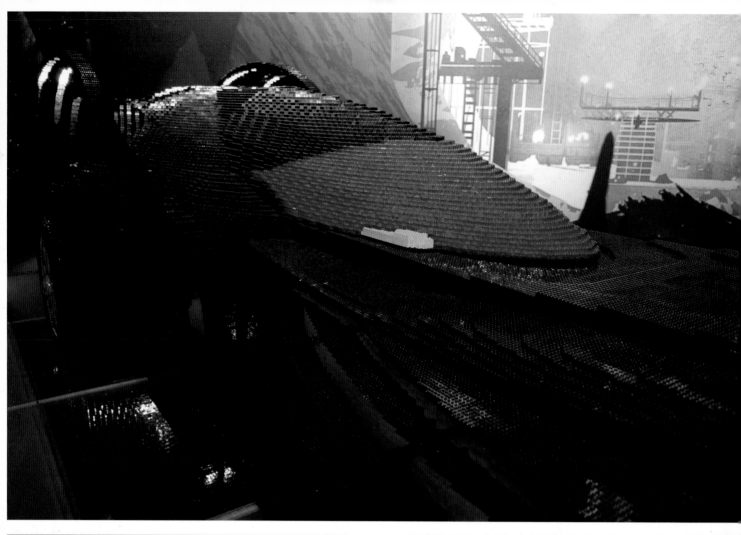

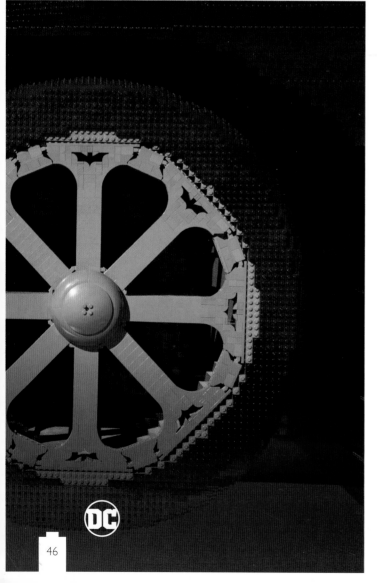

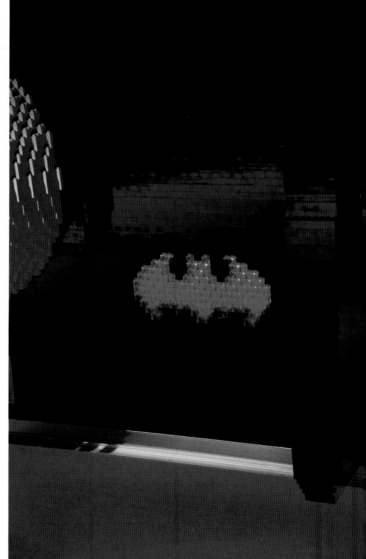

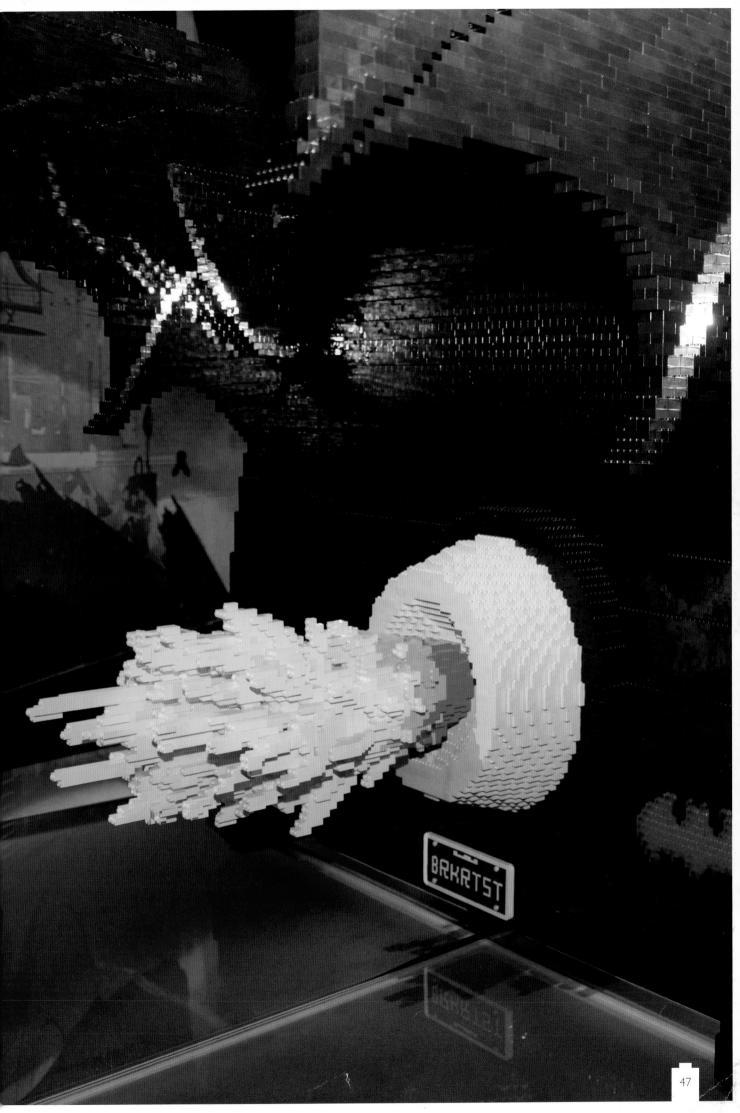

THE FORBIDDEN CITY, BEIJING, CHINA

When the Macau Museum of Art wanted to promote its Forbidden City exhibition with a light-hearted LEGO® build, the country's only LEGO Certified Professional was the obvious person to build it.

Like many LEGO projects that are based on a real-world location or building, the key to Andy Hung's *Forbidden City* was research. Before a single brick had been placed, Hung had already spent two weeks researching and designing so that he understood the details and structures involved in the ornate buildings he was looking to recreate, as well as the bricks that would make his build possible. He also determined how his unglued model would be supported, and how it would separate for the very practical issue of transporting it to the museum.

Each step was carefully calculated to make the actual building process as straightforward as possible, but it still took Hung more than two months to piece the intricate design together. The final step saw him bring the city to life with Minifigure tourists, ready to go on display and raise awareness of the UNESCO World Heritage Site.

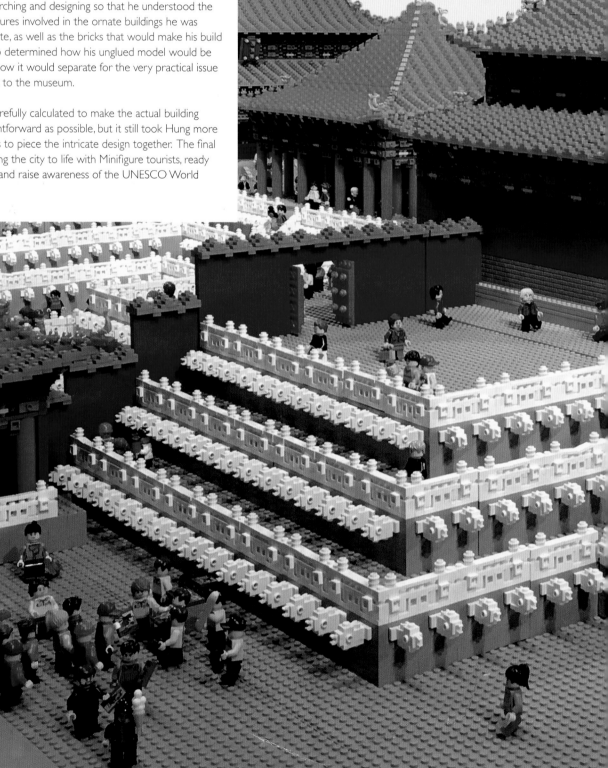

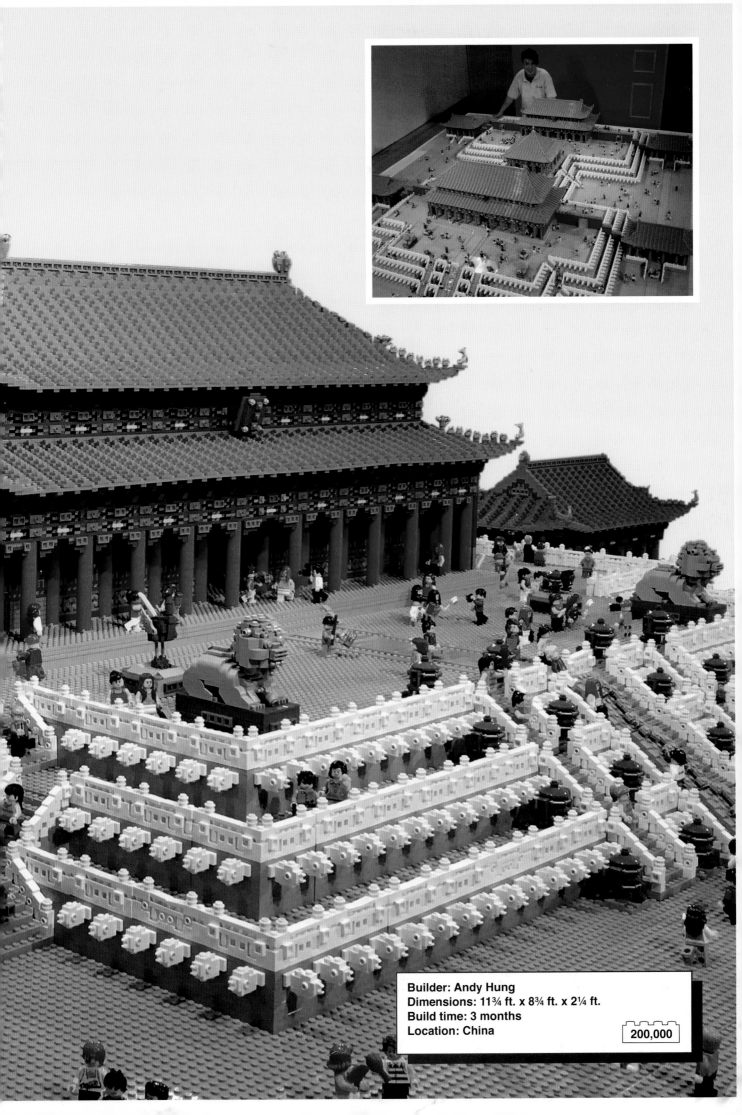

Builder: Andy Hung
Dimensions: 11¾ ft. x 8¾ ft. x 2¼ ft.
Build time: 3 months
Location: China

200,000

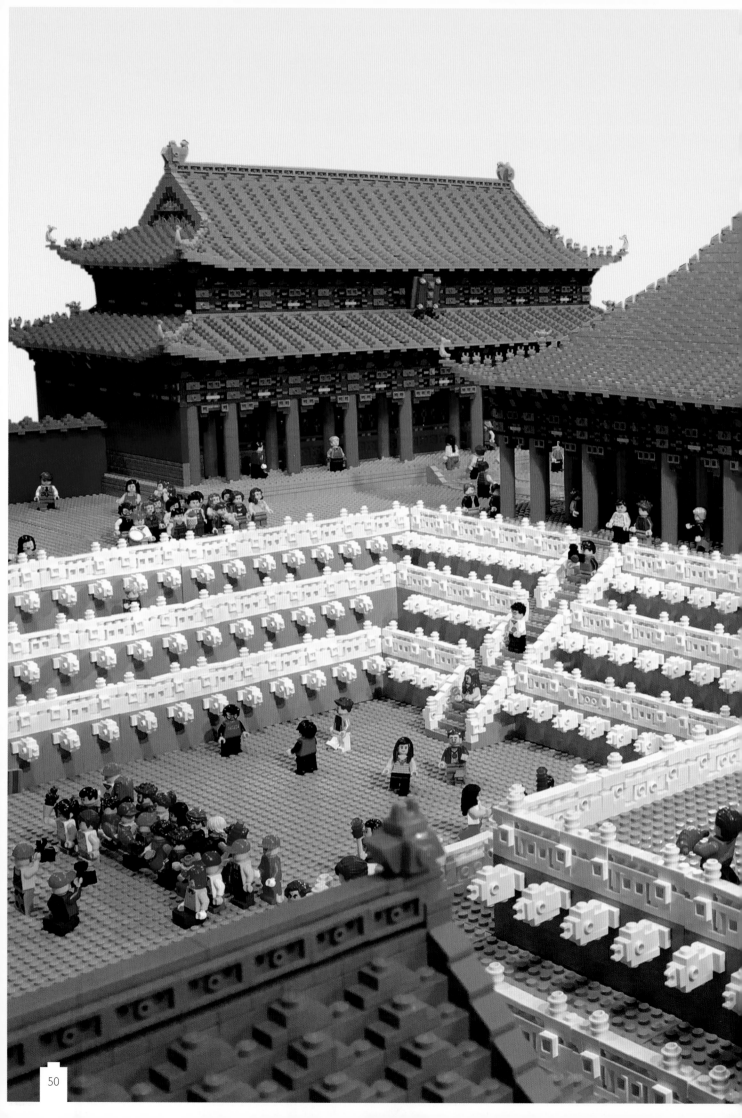

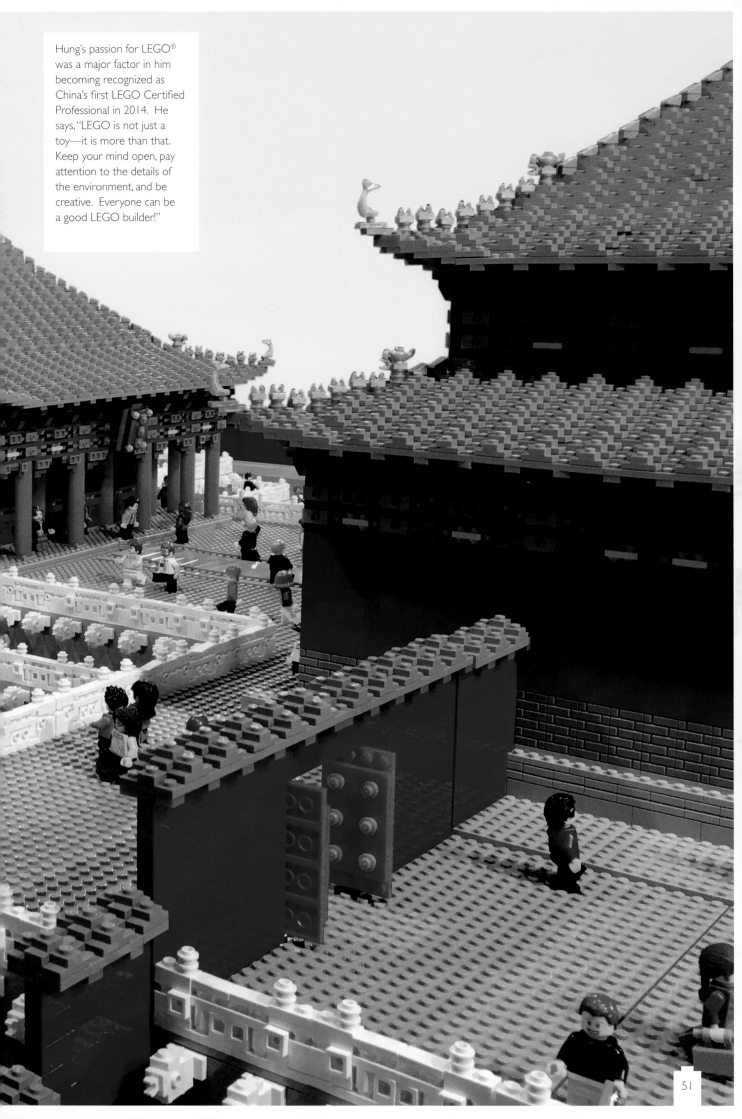

Hung's passion for LEGO® was a major factor in him becoming recognized as China's first LEGO Certified Professional in 2014. He says, "LEGO is not just a toy—it is more than that. Keep your mind open, pay attention to the details of the environment, and be creative. Everyone can be a good LEGO builder!"

TARZAN VERSUS THE LION

A LEGO® mosaic makes a great piece of wall art, whether you're making a portrait, recreating a classic painting, or—in Douglas Dreier's case—producing a brick-based replica of a vintage comic book cover.

As the executive director of a private museum, Dreier, along with the museum's curator, Shyam Bahadur, is in the enviable position of being able to combine work with a love of LEGO. Whenever there's downtime in the office they can head to their dedicated build space and "break out the bricks" to work on a personal project or to collaborate and build a mosaic based on their shared passions of pop culture and pixel art.

This is not always purely to "escape" from the office, though, as their collaborative mosaics all relate in some way to one of the collections the museum holds. *Tarzan Versus The Lion* is the fifth mosaic the pair has made together and came about when Dreier and Bahadur were looking for something to fill an area by the museum's *Tarzan* book collection. Dreier realized that the colors on this 1940s comic book cover would work perfectly, so he ran the artwork through the now-defunct *BrickIt* web app, converting it into a pixelated mosaic design. After a significant amount of post-processing work the relevant bricks were ordered and the pair started piecing the artwork together. About three weeks (and 38,000 bricks) later their stunning, supersized retro wall art was ready to hang.

Builders: Douglas Dreier & Shyam Bahadur
Dimensions: 55 in. x 80 in.
Build time: approx. 21 days
Location: U.S.

38,000

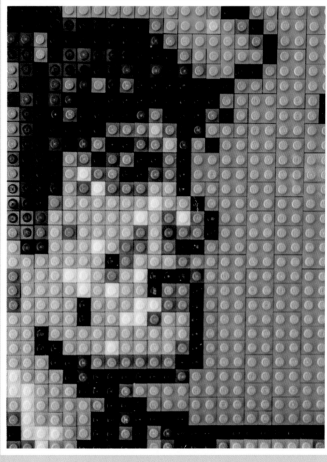

TARZAN

10¢

64 PAGES IN FULL COLOR! DB

UNCHAIN
MY HEART

Paul Hetherington's humanoid robot was inspired by the steampunk art of Kazuhiko Nakamura and was brought to life with an eclectic mix of gold and chrome LEGO® elements.

Hetherington's underlying idea was to symbolize the heart of an introvert, with the robot representing the walls that people can put up, holding themselves back from love. Here, the robot has removed the heart from its chest and is about to sever the chains with the blade on its right arm. If it can do this, the heart's owner will be free to love the woman coming toward him.

Although Hetherington has created models in a similar scale before, this was his first attempt at making surrealist art, and it is his largest organic form. The first two weeks of construction were spent "doodling" with various chrome and gold parts. During this time Paul made as many small, robotic-looking assemblies as he could imagine, using a combination of System, Technic, Bionicle, and Hero Factory parts—there are even parts from a remote control LEGO car.

Thanks to this preparation Hetherington had lots of sub-assemblies already made when he started work on the main body of the robot, so he could simply fit them into the chest, back, and head. In the end, the glue-less model took him two months to design and build—the biggest challenge was getting the proportions and curves right for the face and head.

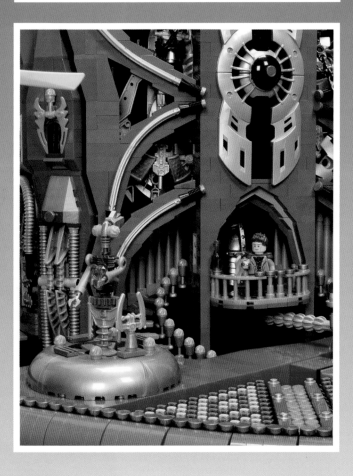

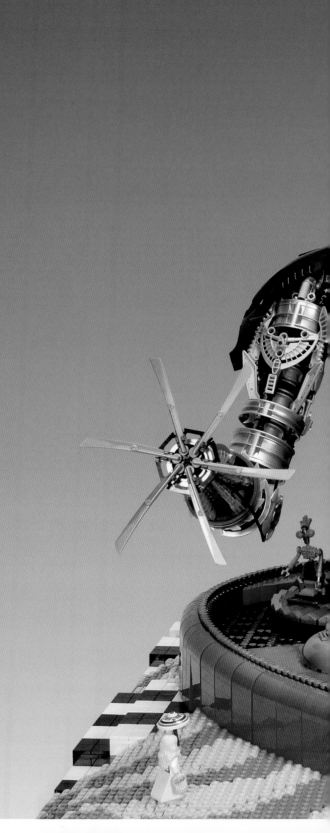

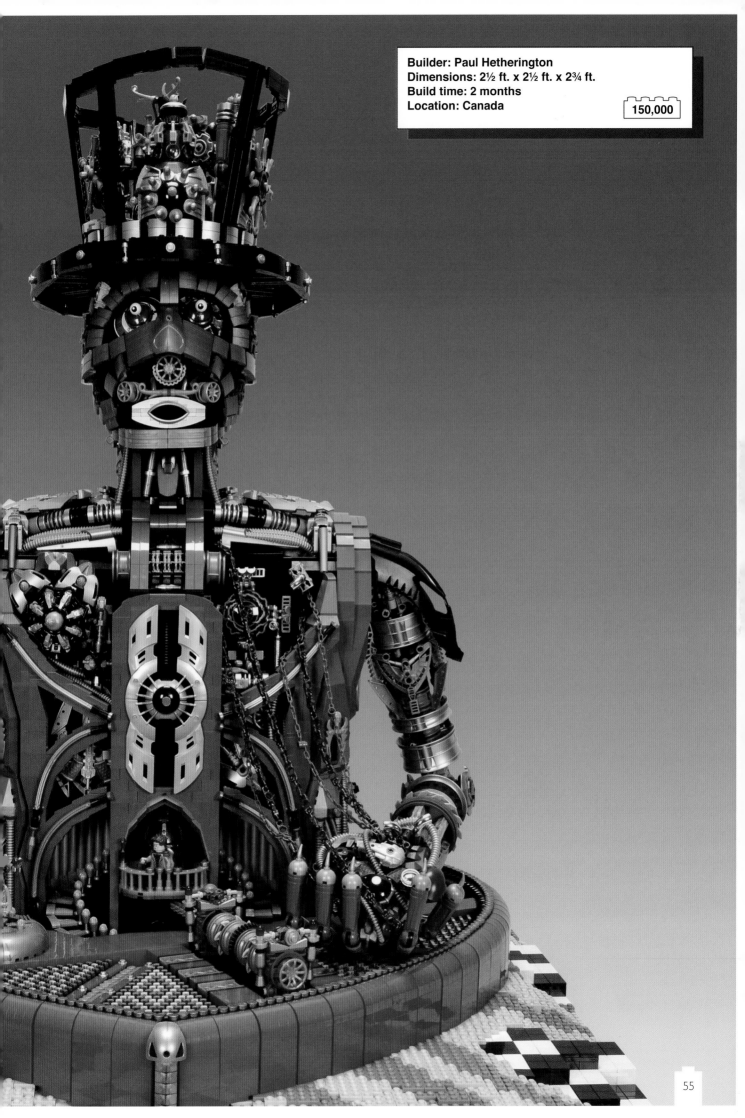

Builder: Paul Hetherington
Dimensions: 2½ ft. x 2½ ft. x 2¾ ft.
Build time: 2 months
Location: Canada

150,000

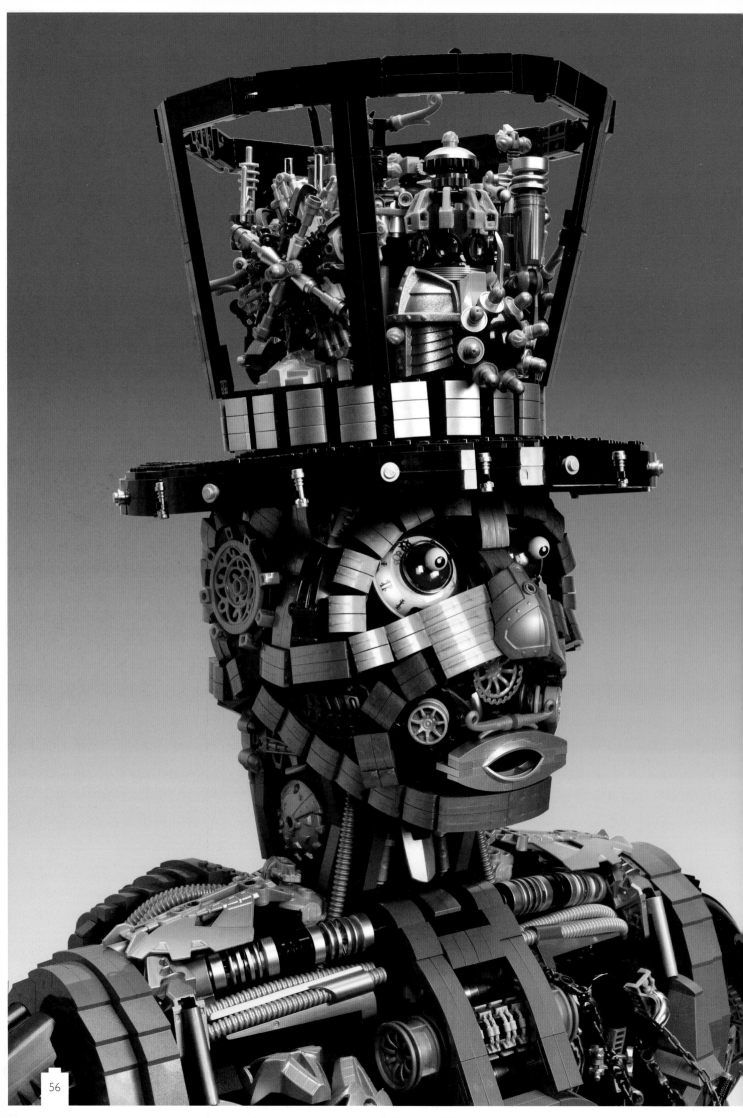

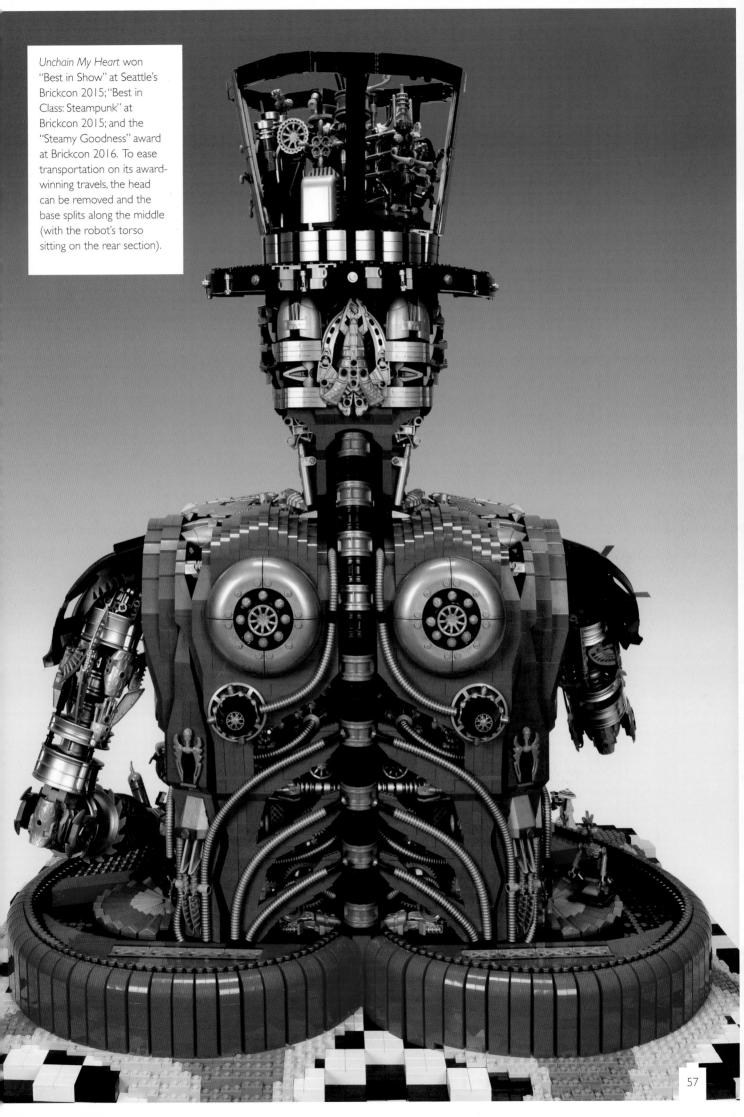

Unchain My Heart won "Best in Show" at Seattle's Brickcon 2015; "Best in Class: Steampunk" at Brickcon 2015; and the "Steamy Goodness" award at Brickcon 2016. To ease transportation on its award-winning travels, the head can be removed and the base splits along the middle (with the robot's torso sitting on the rear section).

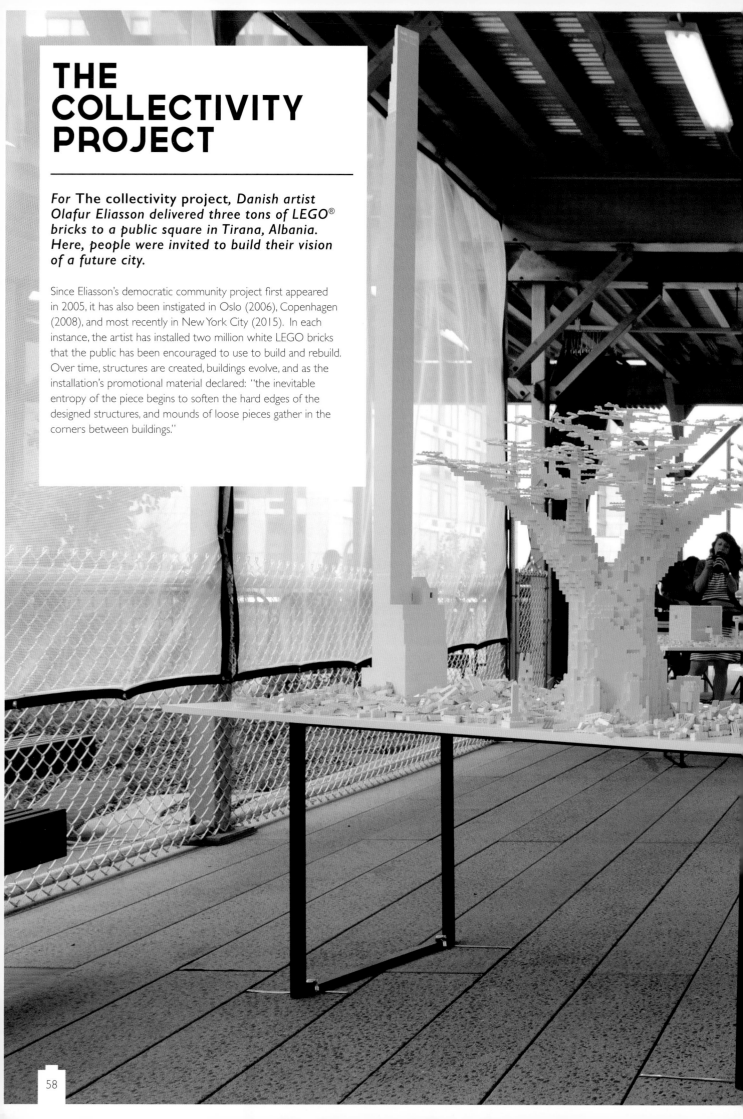

THE COLLECTIVITY PROJECT

For The collectivity project, *Danish artist Olafur Eliasson delivered three tons of LEGO® bricks to a public square in Tirana, Albania. Here, people were invited to build their vision of a future city.*

Since Eliasson's democratic community project first appeared in 2005, it has also been instigated in Oslo (2006), Copenhagen (2008), and most recently in New York City (2015). In each instance, the artist has installed two million white LEGO bricks that the public has been encouraged to use to build and rebuild. Over time, structures are created, buildings evolve, and as the installation's promotional material declared: "the inevitable entropy of the piece begins to soften the hard edges of the designed structures, and mounds of loose pieces gather in the corners between buildings."

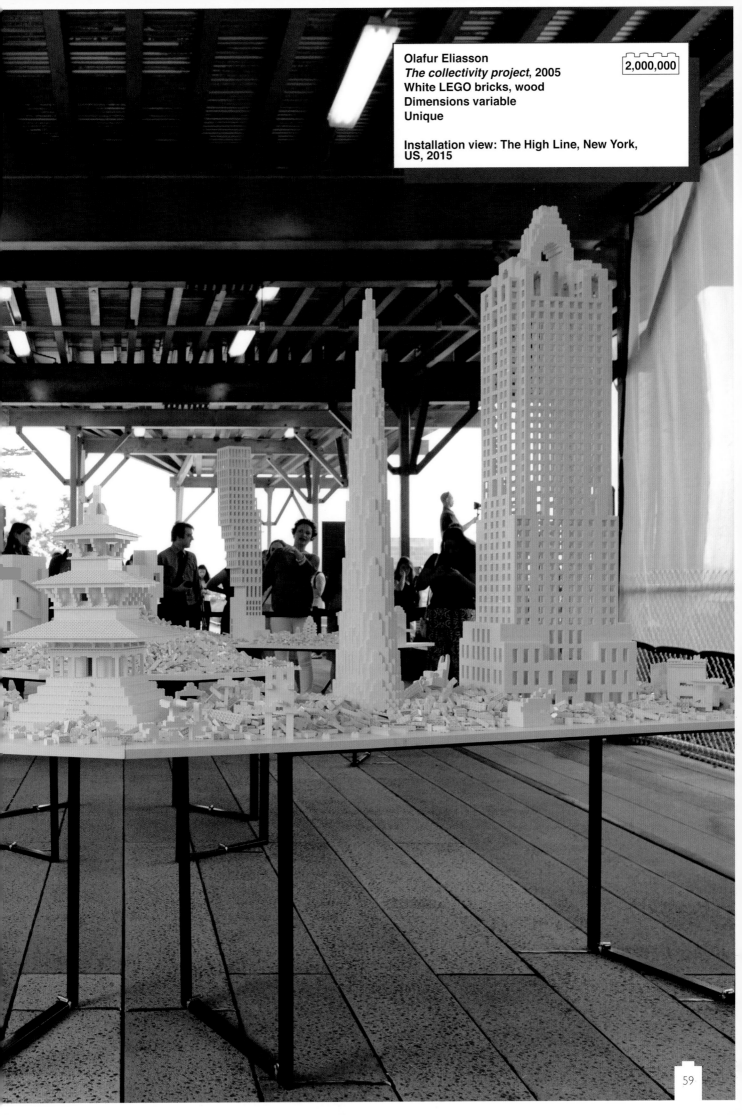

Olafur Eliasson
The collectivity project, 2005
White LEGO bricks, wood
Dimensions variable
Unique

Installation view: The High Line, New York, US, 2015

2,000,000

OHIO STADIUM

With more than three quarters of a million LEGO® bricks used in its construction and a footprint in excess of 55 square feet, Paul Janssen's recreation of Ohio Stadium certainly qualifies as a "big build!"

The inspiration behind Janssen's project was simple: he's a fan of the Ohio State Buckeyes, who call the stadium their home, and he also works at Ohio State University, which is where it can be found. So what better way to celebrate this significant part of his life than with a brick-based build?

Yet while inspiration was easy to find, the construction was far less straightforward. The biggest challenge was creating the ever-changing curves—both inside and out—on a stadium nicknamed "The Horseshoe." However, Janssen's attention to detail (and almost super-human reserves of perseverance) eventually paid off, and more than five years after the first block was put down his not-so-small stadium recreation was complete, ready to receive plenty of well-deserved media attention!

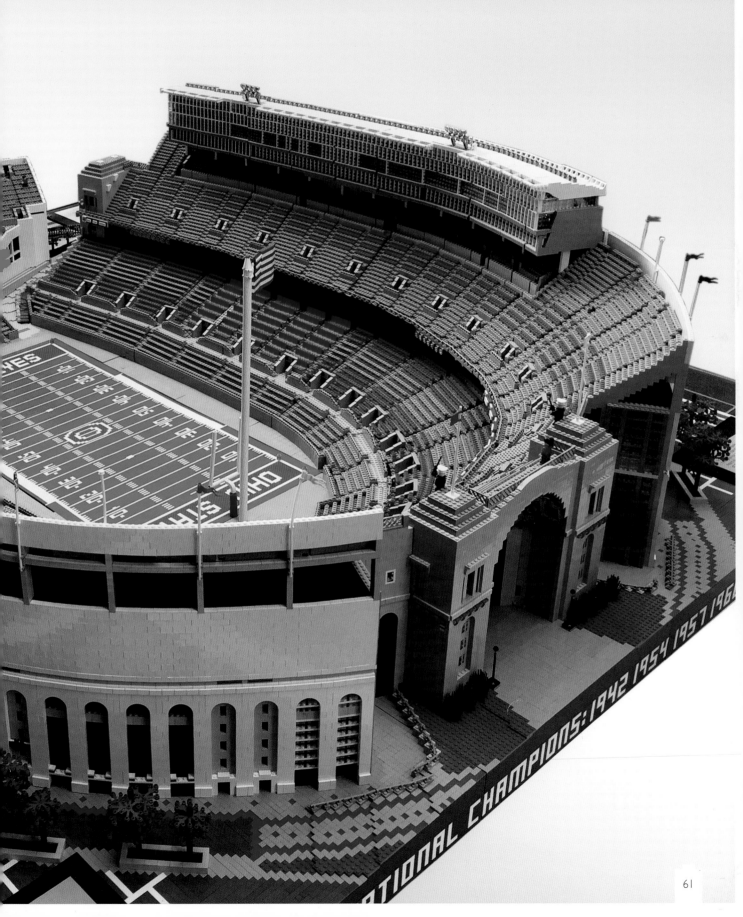

A BEAR IN HIS NATURAL HABITAT

While some people relax and challenge themselves by playing video games, Brandon Griffith gets his kicks from building with LEGO®.

The inspiration for this build came to Griffith while he was watching a nature documentary. In the film, bears were "fishing" for salmon in a river, and as the comedic characters waited for fish to leap into their mouths, Griffith pictured a bear in fishing gear holding his latest catch—something he decided he wanted to commit to brick.

Standing at just over 6 feet tall, the comical figure is the largest sculpture Griffith has tackled on his own, so there were some tricky elements to contend with. Creating a realistic-looking fishing vest was particularly challenging, as it needed to appear separate from the bear, but still suggest the figure's curves beneath it. Griffith also had to work to get the expression right. Although he initially built the model without eyelids, this gave the bear a shocked and scared expression. Adding eyelids "really calmed him down and made him more friendly," giving Griffith's fisherman the naturally comedic character he had envisaged.

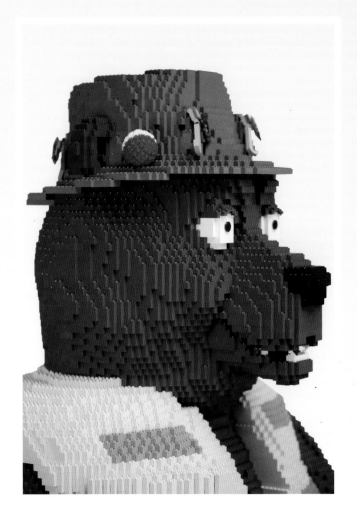

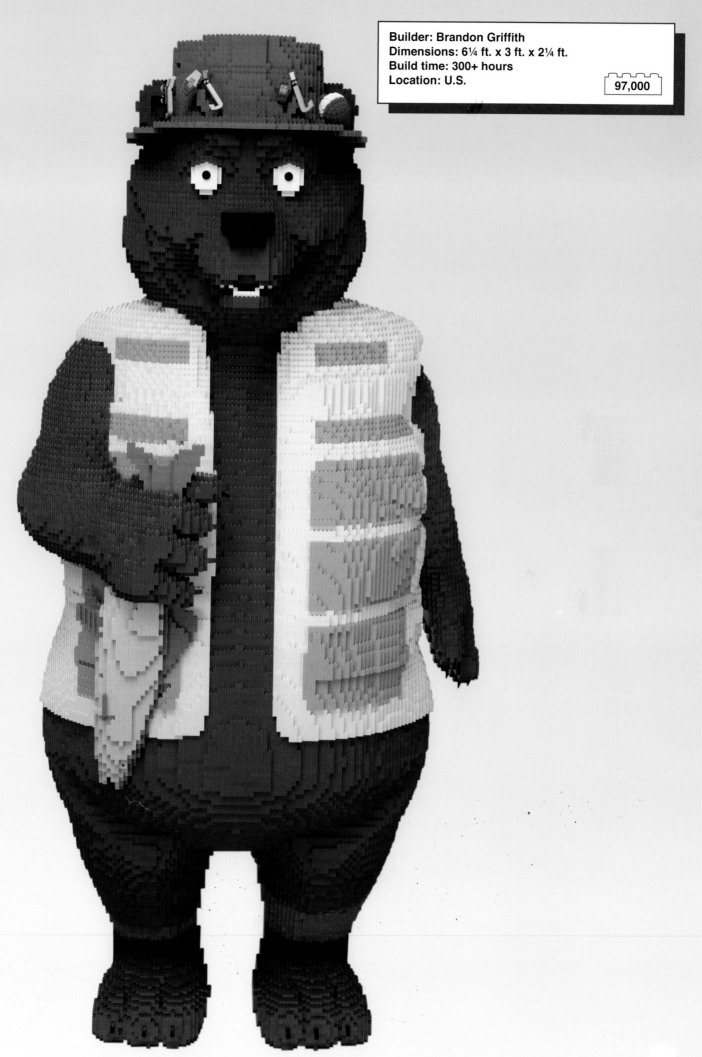

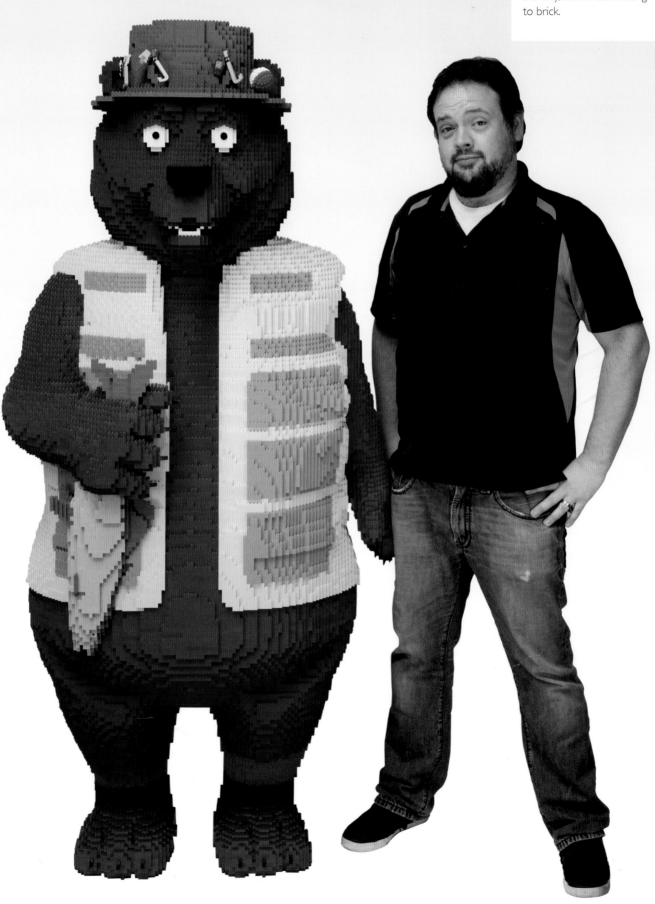

Griffith's build started life as a digital model built using *Bricksmith* software. Although it takes a while to design a LEGO® build on a computer, Griffith likes that he can make changes along the way, before committing to brick.

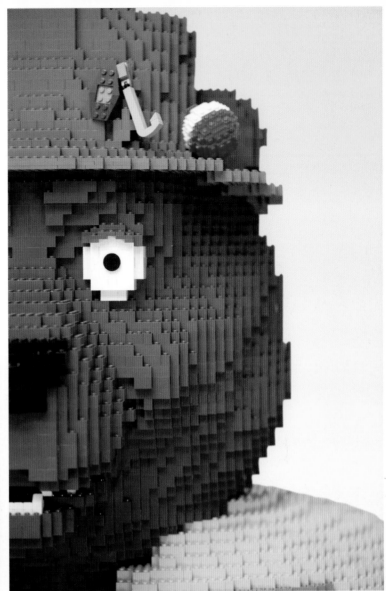

AMERICAN EAGLE ROLLER COASTER

Adam Reed Tucker has been working artistically with LEGO® bricks since 2006, during which time he has created the LEGO Architecture range, co-founded the Brickworld Chicago event, and produced some exceptional builds.

With a background in architecture, Tucker's projects are invariably based on real-world structures and this impressive roller coaster is no exception. The LEGO Certified Professional didn't have to look far for inspiration, as the "full size" American Eagle roller coaster is found at Six Flags Great America theme park in Gurnee, Illinois, just forty miles north of the Chicago-based builder's home.

This made it possible for Tucker to get "up close and personal" with the wooden roller coaster, so he could study first-hand the engineering involved in the build. Yet even with this access to the original structure, the design process for the model still took more than fifty hours, with twice as much time again spent piecing it together. The greatest challenge was the triangulating framing structure. Not only does it consist of many unorthodox angles and connection points, but as with all of Tucker's brick builds, these challenging elements needed to be reinterpreted without relying on any glue to hold the pieces together.

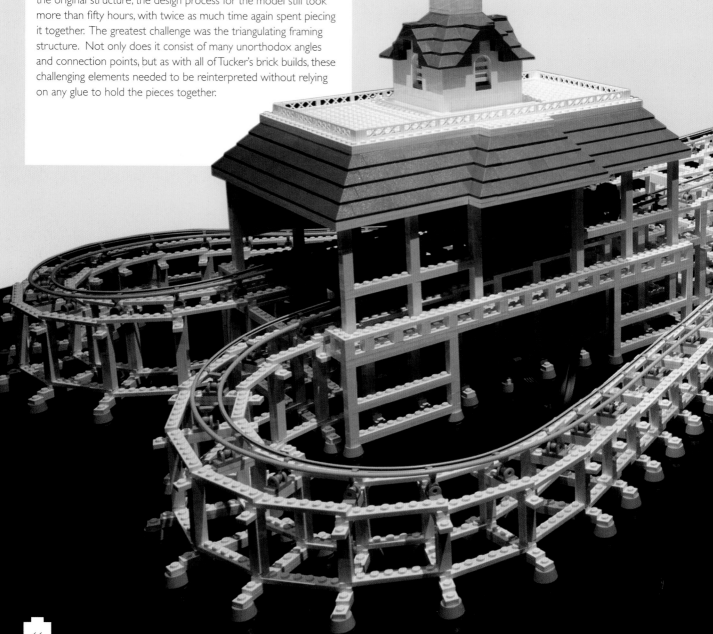

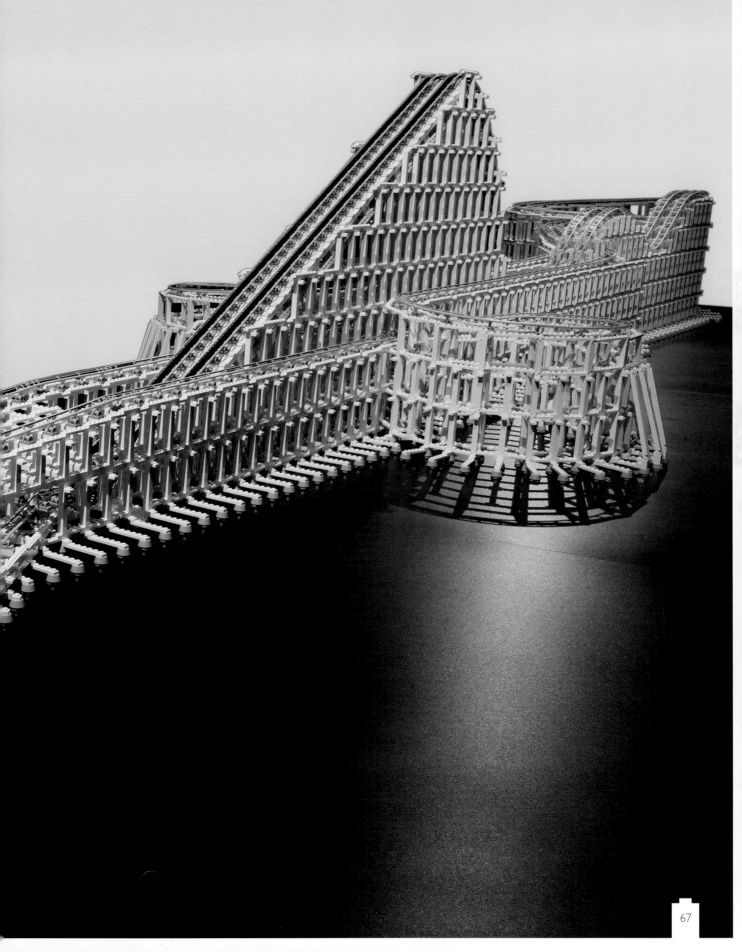

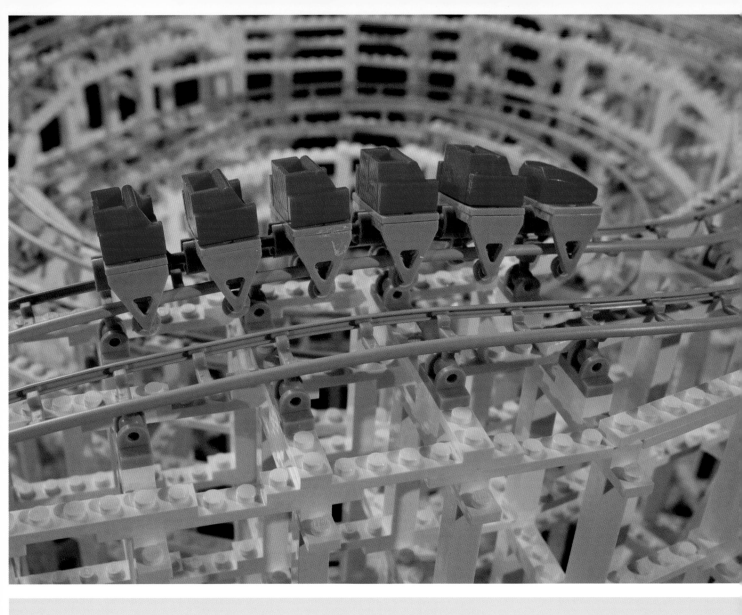

Although the framework for Tucker's roller coaster is made out of LEGO® bricks, the track system is not an "official" LEGO product. Instead it is a compatible system that Tucker designed and produced in conjunction with CoasterDynamix. The resulting *X-Labs Rollercoaster Factory* set was released as a limited edition of 1,000 kits; these have now sold out.

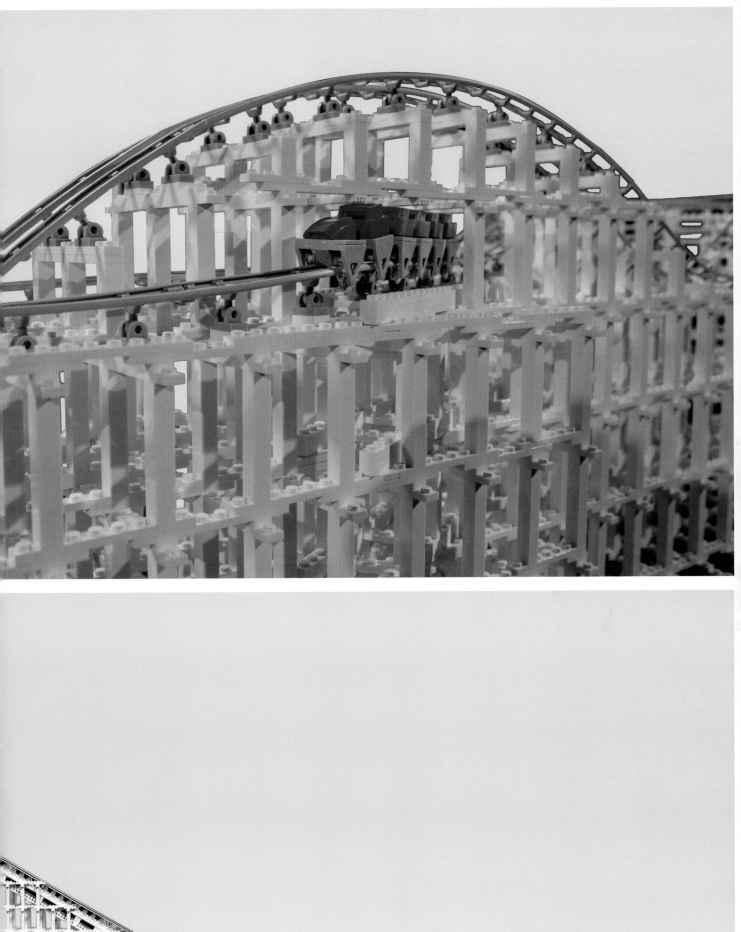
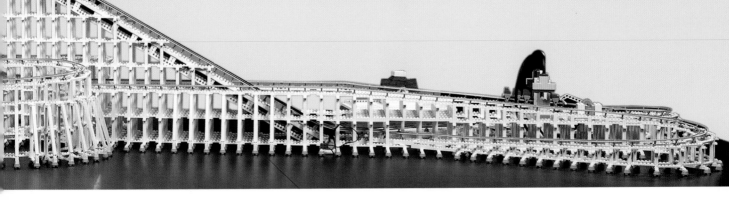

CONTAINMENT

Collaborative builds are a great way to share ideas and explore techniques that you might not attempt on your own. However, it is not always a straightforward process.

When Tyler Clites and Nannan Zhang decided to collaborate for the first time, it was on a project for Brickworld Chicago, so immediately the stakes were higher than if they were undertaking a personal build. Luckily, they knew what they wanted to achieve: "We decided to build a sci-fi diorama, with a factory looming in the background of an alien wasteland. We wanted to create a contrast between the order and productivity of the buildings and the chaos and decay of the landscape, but unify the two elements through the use of color; mainly dark tan and green."

However, although their goal was clear, there was a fairly significant challenge: Clites and Zhang lived in separate states. This meant they had to coordinate everything over Skype and through shared photographs of their progress. That would be daunting enough with a static build, but their model also featured a moving monorail and a working ball factory.

It wasn't until days before the convention that they met up to assemble everything and see how it all turned out. Thankfully it all came together perfectly, and for their display they even managed to add lights and build in an iPod speaker to play sci-fi music during the show. With that level of success it's hardly surprising that the pair has gone on to collaborate on further projects!

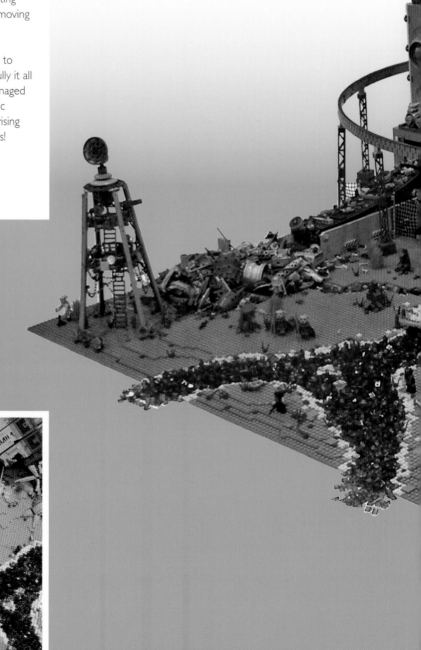

Builders: Tyler Clites & Nannan Zhang
Dimensions: 5 ft. x 7 ft.
Build time: 2 months
Location: U.S.

10,000+

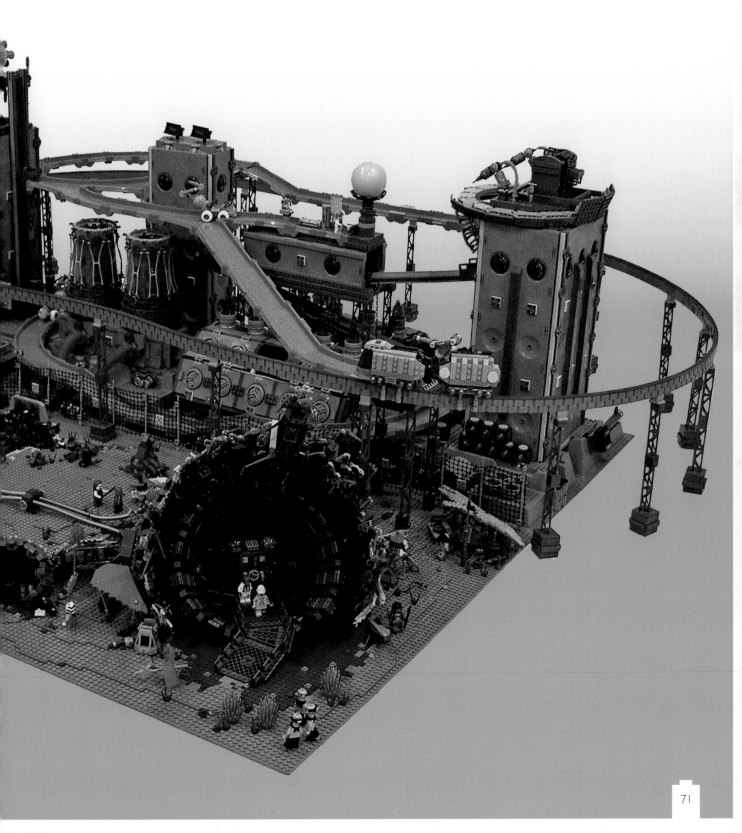

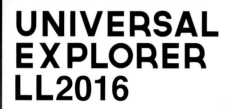

UNIVERSAL EXPLORER LL2016

*Constructed from more than 15,000 LEGO® pieces, Mark Neumann's **Universal Explorer LL2016** is a fully fledged "SHIP" project— or "Seriously Huge Investment in Parts."*

Neumann came up with the concept for his spacecraft while he was discussing modular SHIP building with a friend. He immediately took the idea to brick, making a mock-up to see if it would work. When he realized it was indeed feasible, he set to work properly, investing about 120 hours over evenings and weekends to create three modules for the front section, cargo section, and engine section. He then ran with the idea, producing five more sections to expand his interstellar explorer.

As he enjoys the non-permanence of LEGO, Neumann's model isn't glued—in fact, to build *Universal Explorer LL2016*, around thirty earlier models needed to be deconstructed and sorted. Yet despite the time spent on it, *Universal Explorer LL2016* will also one day be deconstructed so another creation can come to life.

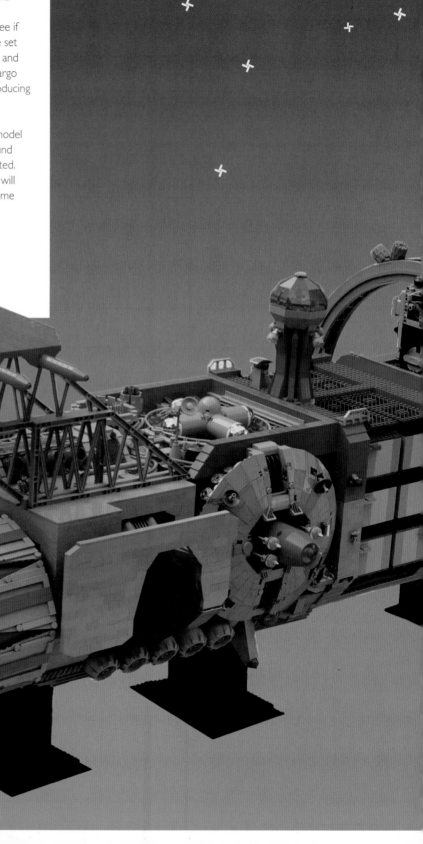

Builder: Mark Neumann
Dimensions: 12 ft. x 4 ft. x 4 ft.
Build time: approx. 120 hours
Location: U.S.

15,000+

LL 2016

Neumann's large-scale build isn't just about its exterior. Doors in the side allow access to the interior of the spacecraft, where smaller ships, giant robots, and crew members can be found.

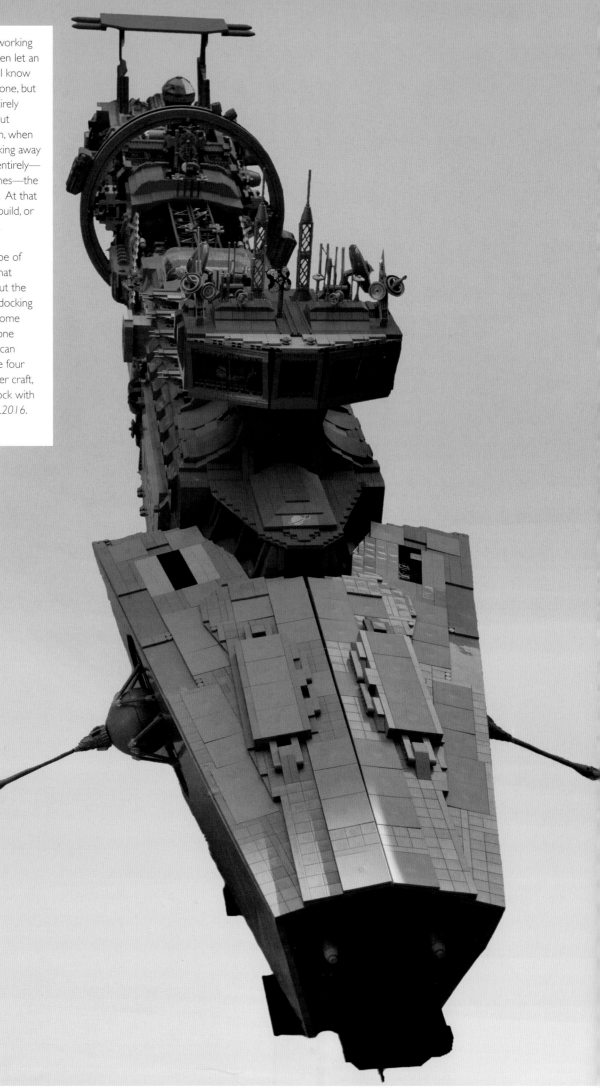

When Neumann's working on a model, he'll often let an idea percolate. He'll know what needs to be done, but won't always be entirely sure how to go about constructing it. Then, when he's mindlessly working away on something else entirely—such as washing dishes—the solution will hit him. At that moment he *has* to build, or the idea will be lost.

It is precisely this type of "Eureka" moment that helped him figure out the mechanism for the docking clamps. Thanks to some clever engineering, one spring-loaded lever can hold and release the four arms that grip smaller craft, enabling them to dock with *Universal Explorer LL2016*.

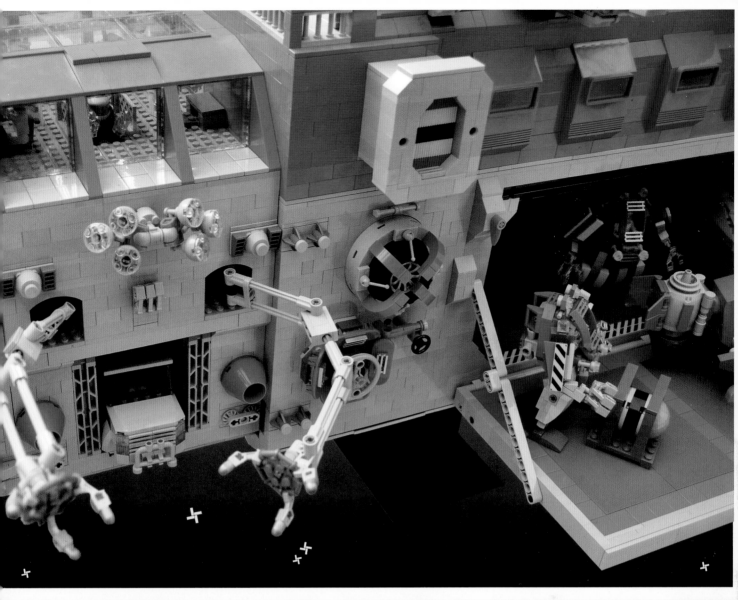

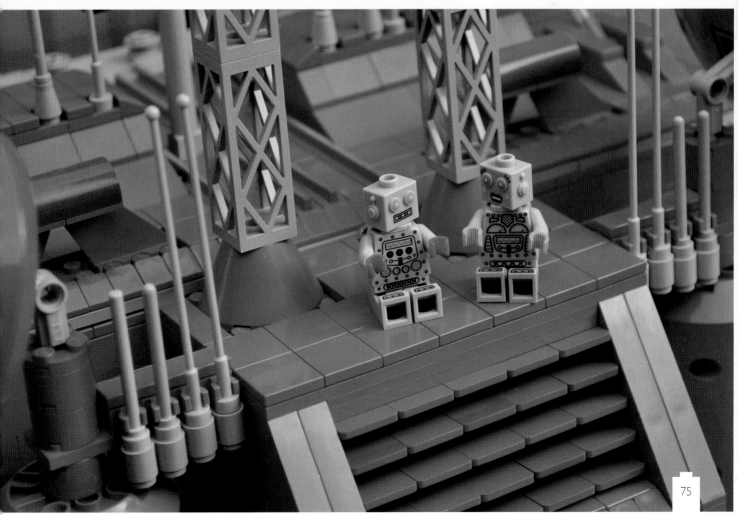

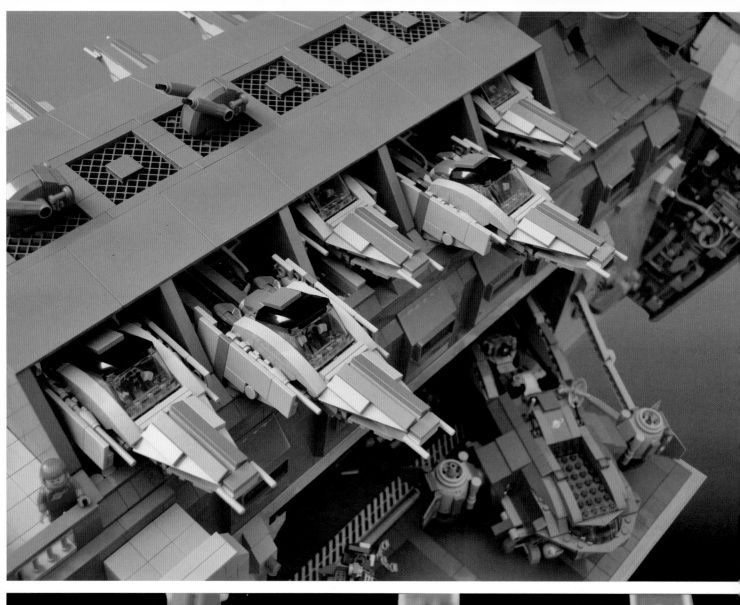

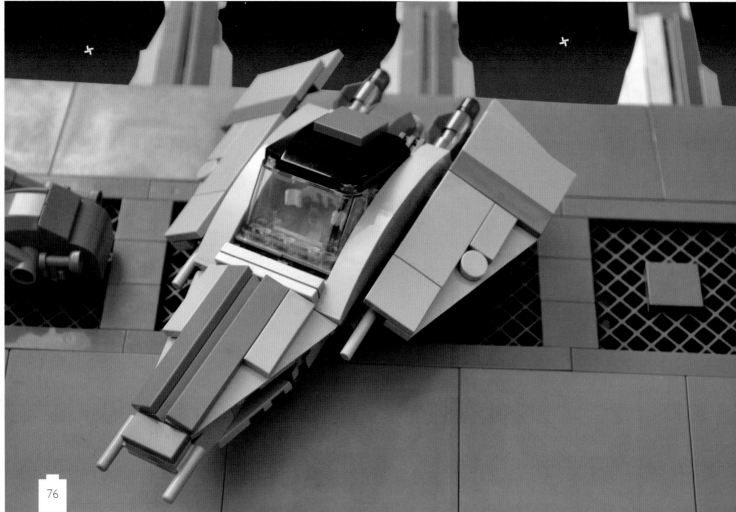

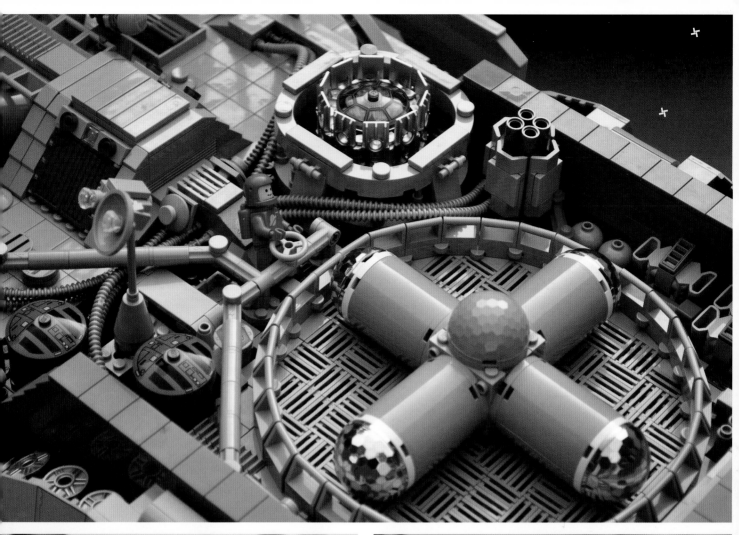

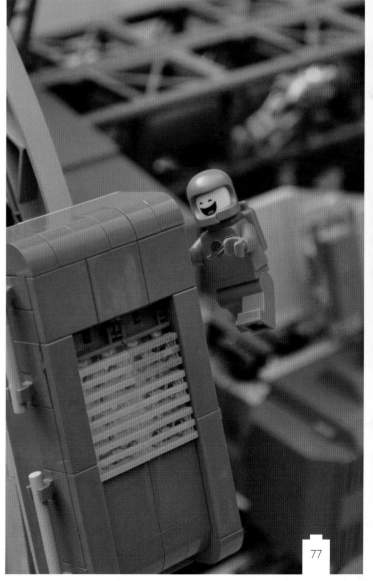

POINT DUME RESIDENCE

By day, César Soares is a LEGO® model designer, working on the company's Star Wars line, but in his free time he likes to pursue more "down to earth" block builds.

Soares has always been a fan of contemporary architecture and is fascinated by how some houses can also be considered "works of art." This meant he was naturally excited when an architecture company asked him to build a LEGO model depicting the "ultimate modern dream house."

Heading online, Soares looked at hundreds of real examples of modern architecture, initially deciding on a "house in the hills" style setting. However, one day he was driving near the beach when it hit him: if the house had its own private beach, with the door just a few yards from the sand, that would help it look even more dreamy. In an instant, *Point Dume Residence* was born—a fictional house set in a real location in Malibu, California.

Following five to six hours of focused research, the build itself took Soares about seventy hours using original LEGO pieces, which he assembled traditionally, without glue. Balancing stability and realism was a key concern, but the biggest test was the pool. Soares wanted it to look like real water, but that's not easy to do with LEGO bricks. Ultimately, a combination of translucent blue parts and a bit of imagination gave him the result he wanted, and also gave his client the "ultimate dream home."

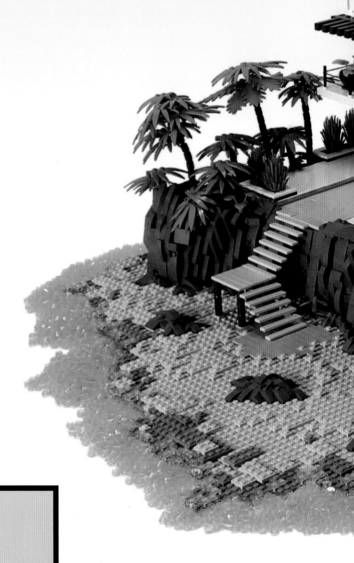

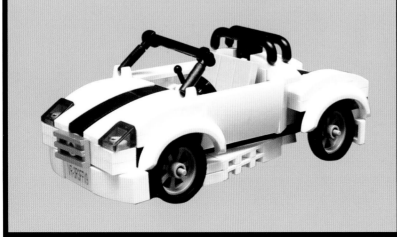

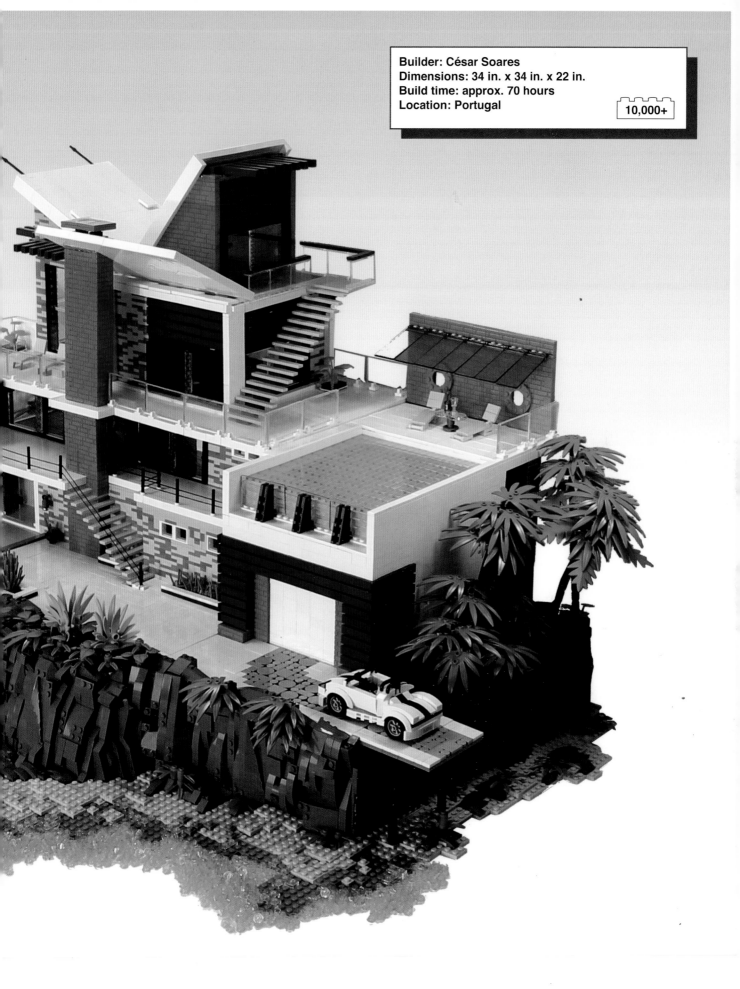

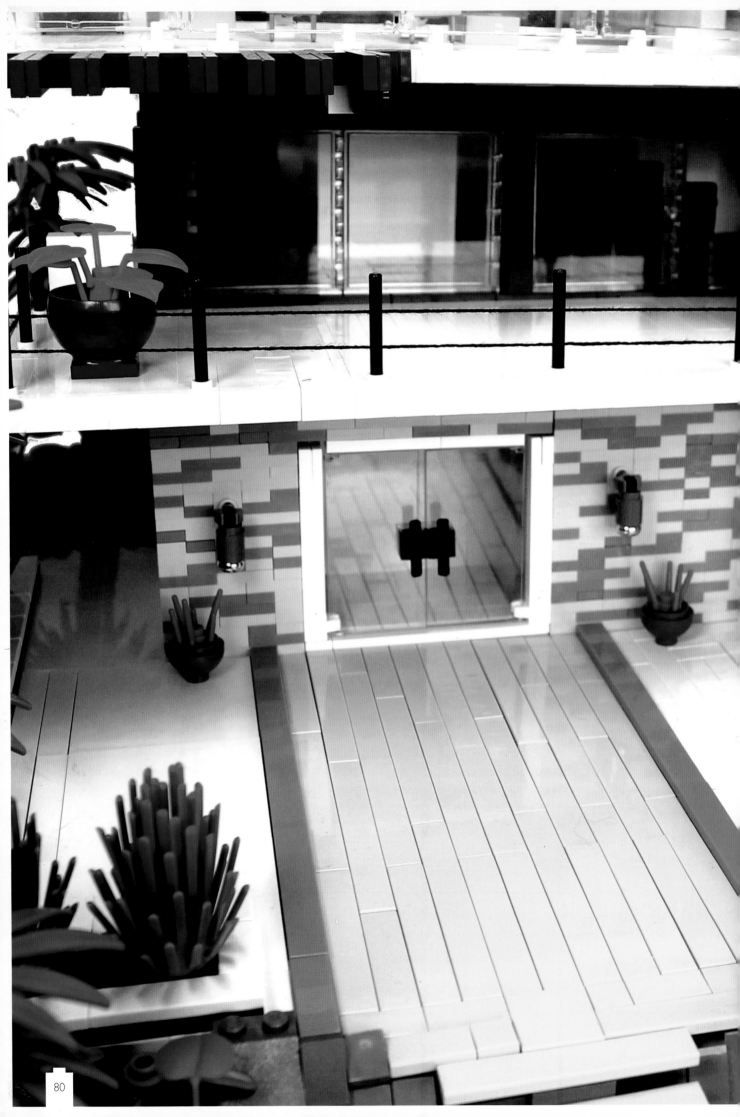

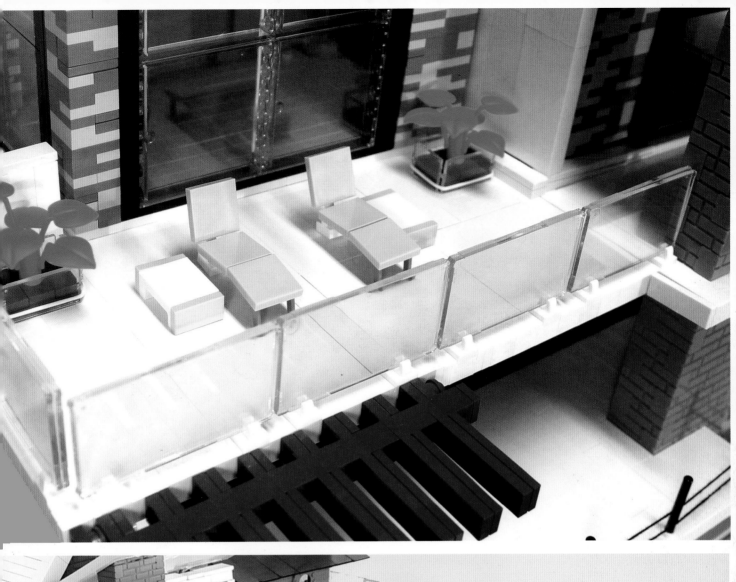

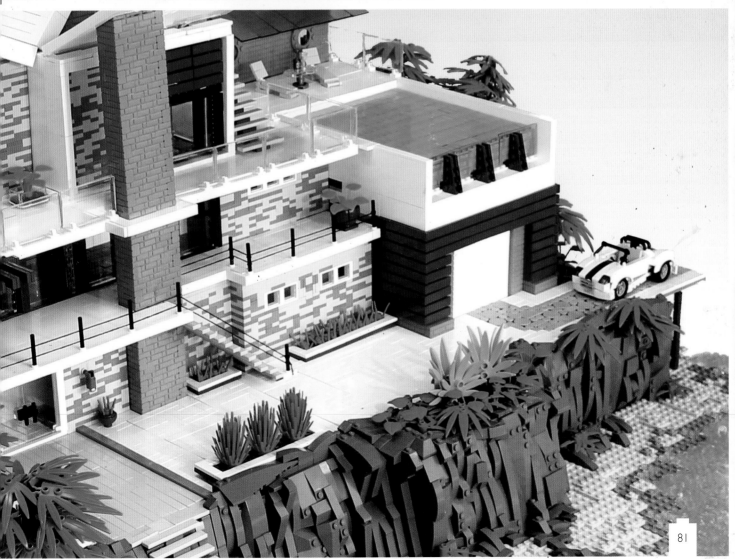

RMS QUEEN MARY

When UK-based LEGO® specialist Bright Bricks needed a centerpiece for its Bricks in Motion *show, the company's co-owner, Ed Diment, knew just what to choose: one of the world's most iconic ocean liners.*

With a life-long interest in ships, Diment is no stranger to maritime LEGO builds. However, at over 25 feet in length, and weighing in at more than 600 pounds, *RMS Queen Mary* is the largest LEGO ship he has worked on and—for a short while—was *the* largest build of its type in the world.

Yet even though this was always going to be a large-scale build, and Bright Bricks had a dedicated 3,000 square foot workshop (now expanded to 10,000 square feet), the workshop was too busy to accommodate the project at the time. Consequently, the record-breaking liner's four-month construction started in the less auspicious setting of Diment's spare bedroom. The first month of the project was spent poring over blueprints of the original Cunard White Star Line ship and scaling them down to Minifigure-scale proportions, then an additional three months were needed for the build process itself.

As the model was originally designed to be a touring asset, it was glued to make the set-up and take-down as easy and damage free as possible. Its travels are now over, though, as the LEGO *RMS Queen Mary* currently resides onboard its full-sized namesake in Long Beach, California.

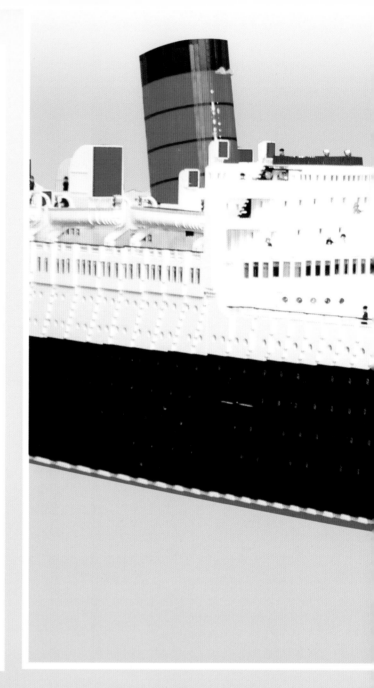

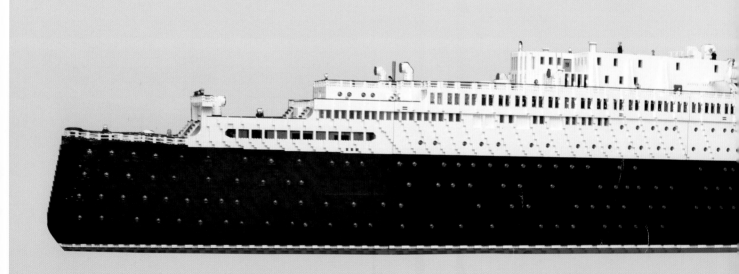

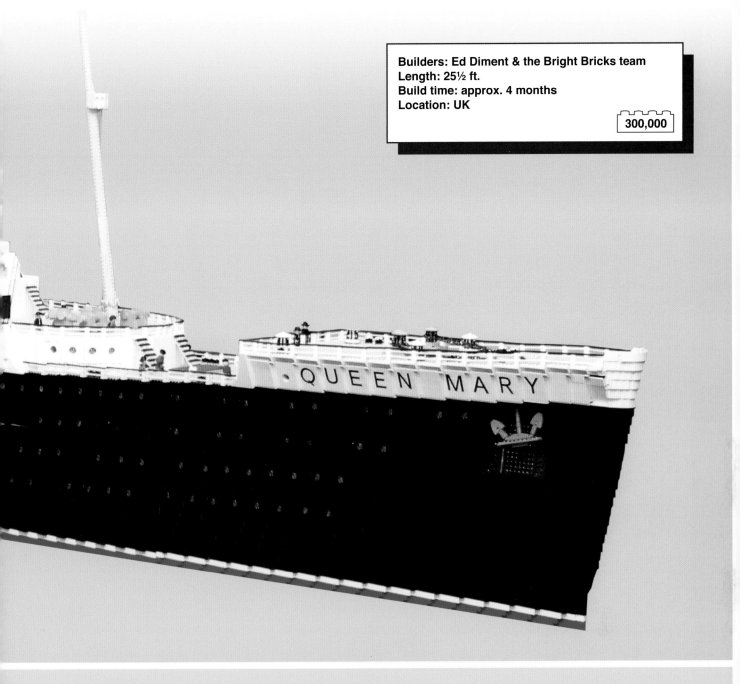

Builders: Ed Diment & the Bright Bricks team
Length: 25½ ft.
Build time: approx. 4 months
Location: UK

300,000

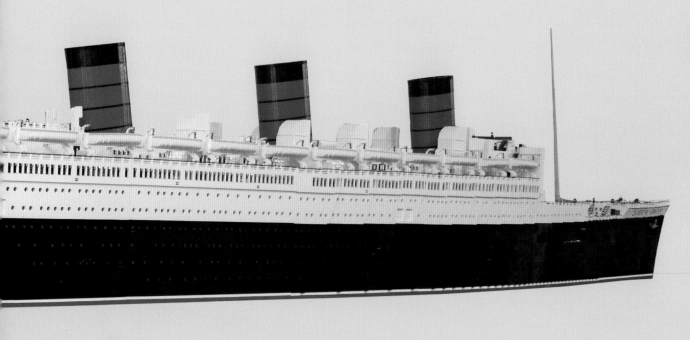

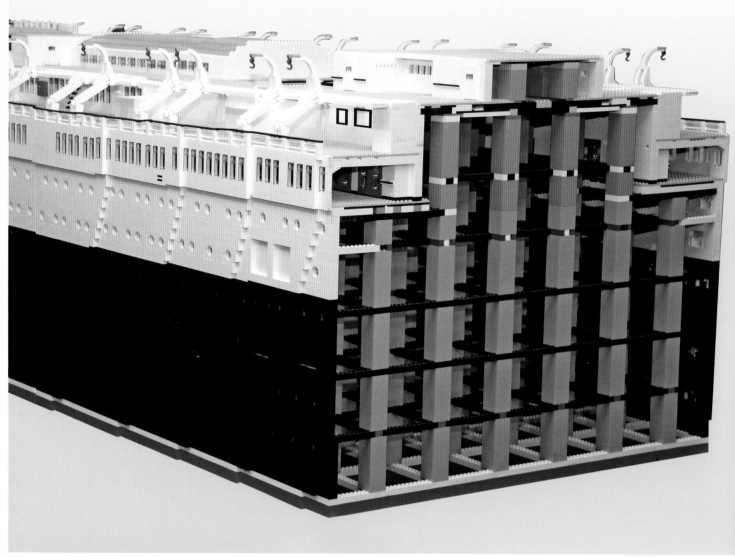

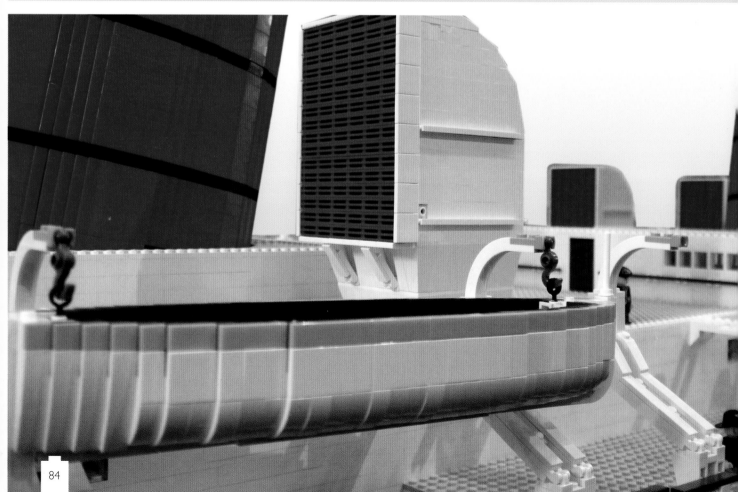

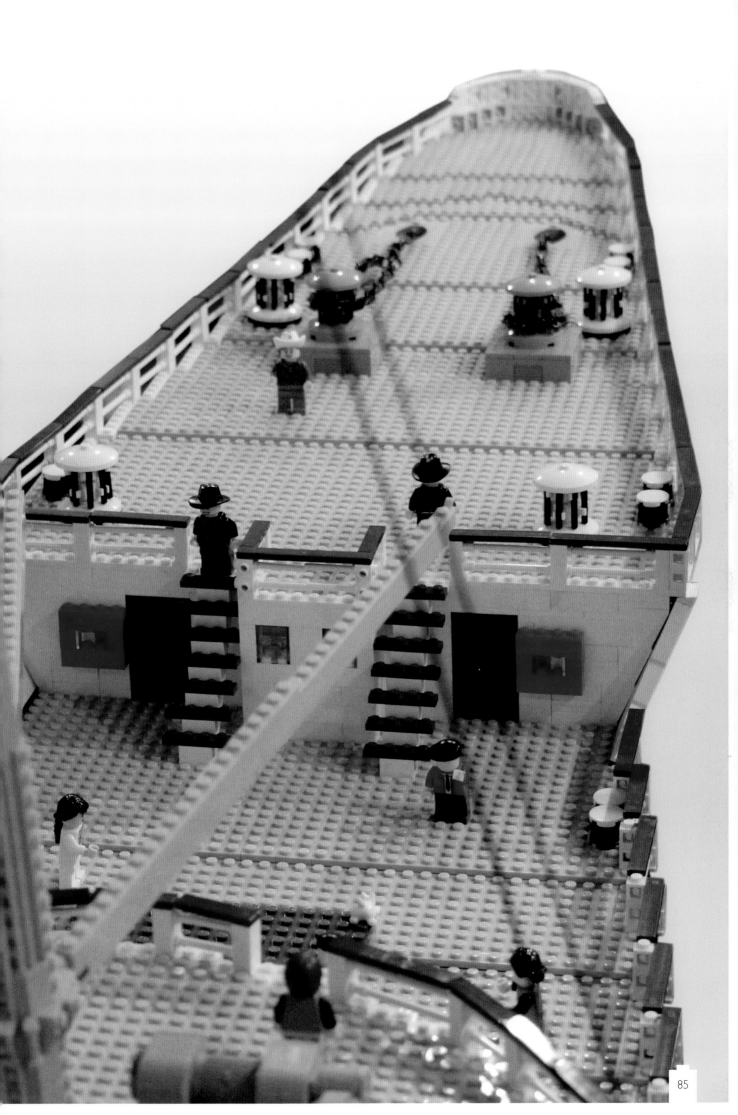

OVERSIZE LEGO® CHAIR

Builder: Alê Jordão
Dimensions: 3½ ft. x 3½ ft. x 6¼ ft.
Build time: approx. 3 months
Location: Brazil

3,000+

For his Oversize LEGO Chair, Alê Jordão decided to combine two of his passions: furniture design and LEGO.

This is not the first time the Brazilian artist has used LEGO in his work, but it is the artist's biggest build to date; his chair stands over 6 feet tall, with a seat that's 3¾ feet from the ground. The build was assembled over a three-month period in Jordão's warehouse studio, using more than 3,000 LEGO bricks. While this is a relatively low brick count compared to many other builds in this book, it still proved difficult to get the materials he needed—the main supplier in Brazil didn't have the stock he required, so he had to rely on smaller models from toy stores.

As it is glued together, the finished piece combines both form and function: the chair not only looks good, but it can also be used as a practical piece of furniture without breaking apart.

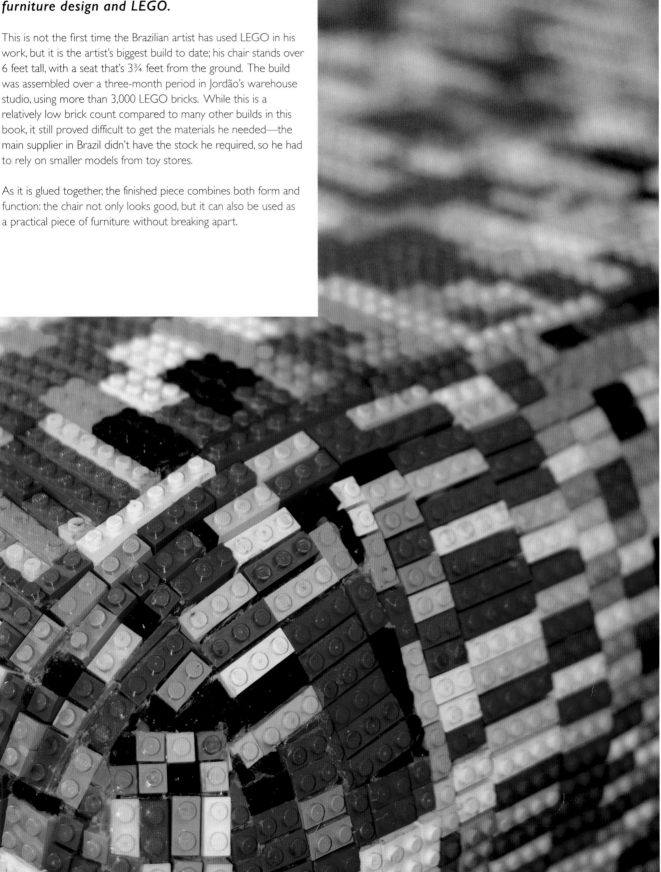

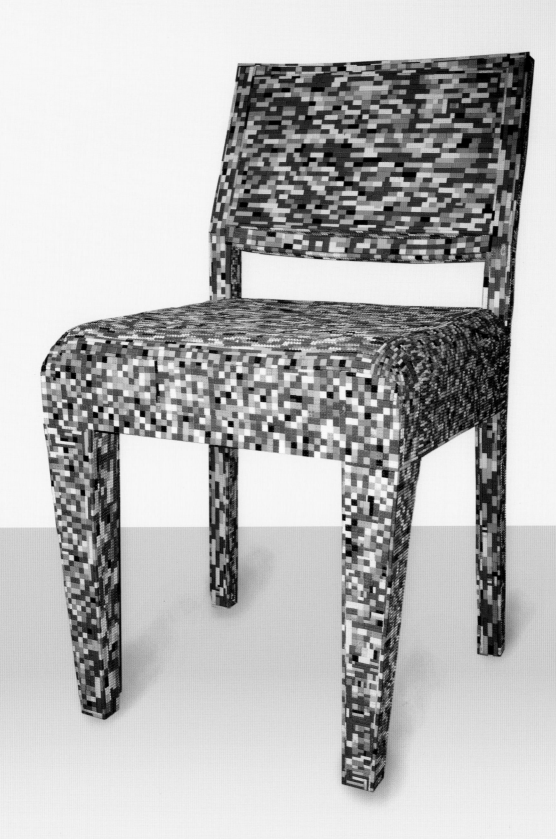

WEST PHOENIX OIL PLATFORM

Although LEGO® Certified Professional Matija Puzar designed this stunning oil platform, it took a team of 300 people to build it!

The project was commissioned by a company that wanted to do a team-building event. The idea was for all the company's employees—some 300 of them in total—to participate in the build. Obviously, having that many people working at the same time would have been impossible, so the workforce was split into groups, and every week two groups would be given a module to build for the project.

This meant that one of Puzar's main challenges was to design and deliver two modules each week, often working to deadlines that meant the parts had to be shipped out overnight. The other major problem was that the oil platform was being built at the company's premises, which were on the opposite side of Norway to Puzar. As a result, the LEGO expert wasn't able to watch the model being built, so he couldn't see how the modules he had sent had come together, or even know if they would work fully together! However, after six months—of which three were spent on the actual build—the model was complete: 36,000 bricks successfully assembled by a team of 300 enthusiastic builders!

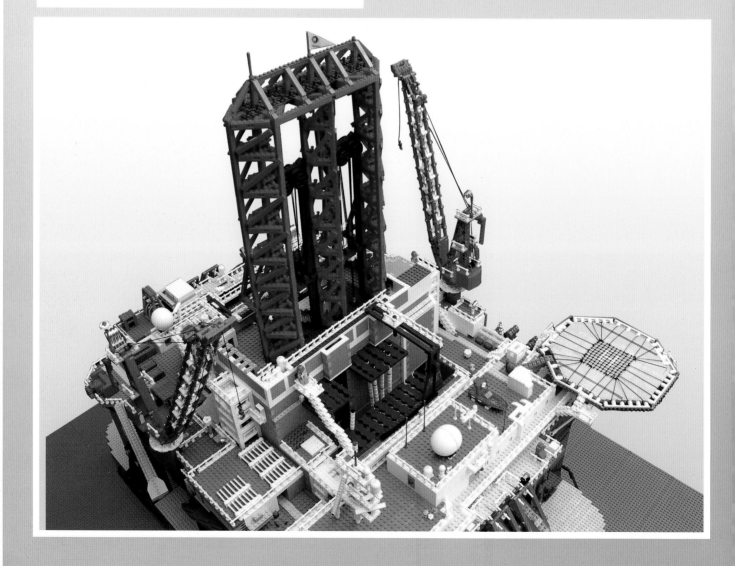

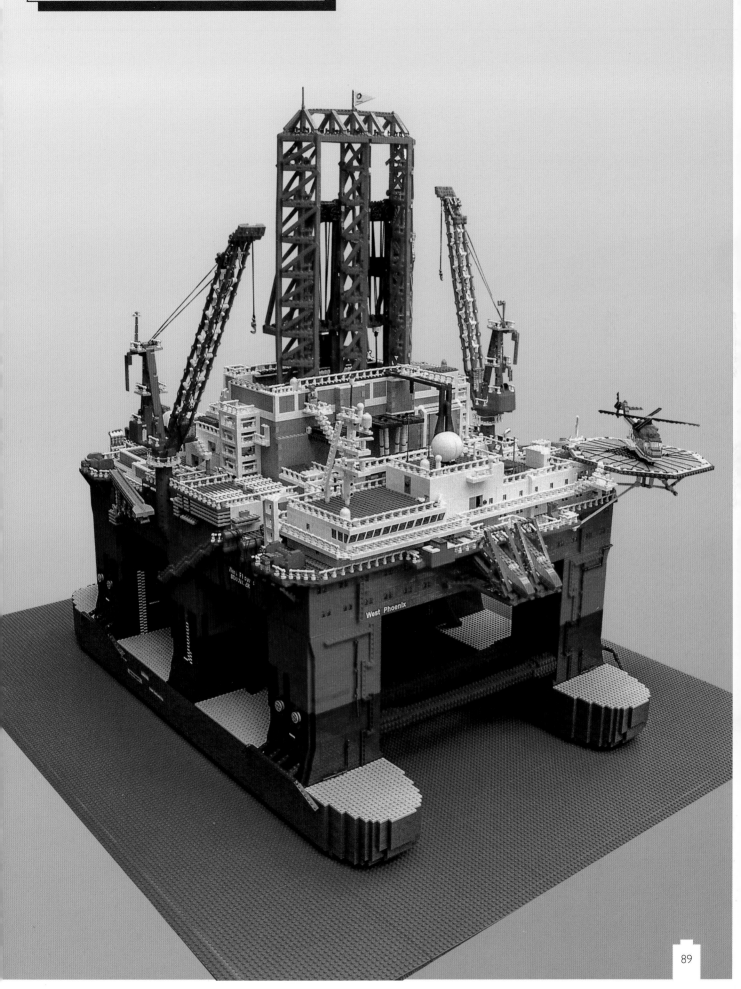

Designer: Matija Puzar
Dimensions: 3 ft. x 4 ft. x 3¾ ft.
Build time: approx. 6 months
Location: Norway

36,000

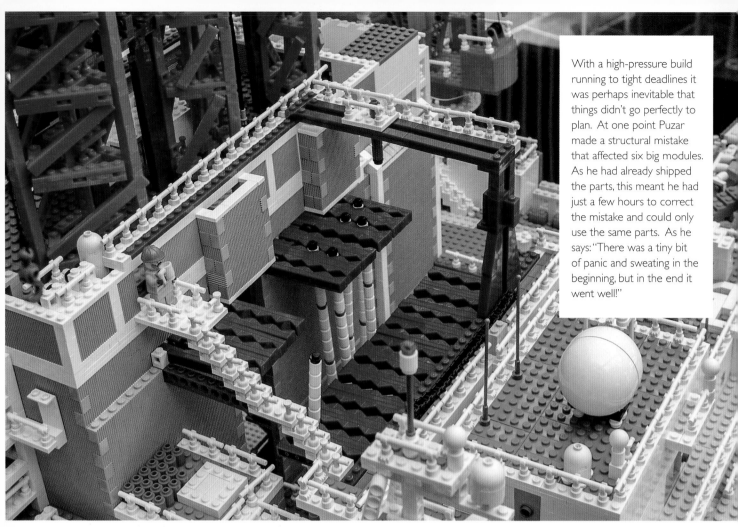

With a high-pressure build running to tight deadlines it was perhaps inevitable that things didn't go perfectly to plan. At one point Puzar made a structural mistake that affected six big modules. As he had already shipped the parts, this meant he had just a few hours to correct the mistake and could only use the same parts. As he says: "There was a tiny bit of panic and sweating in the beginning, but in the end it went well!"

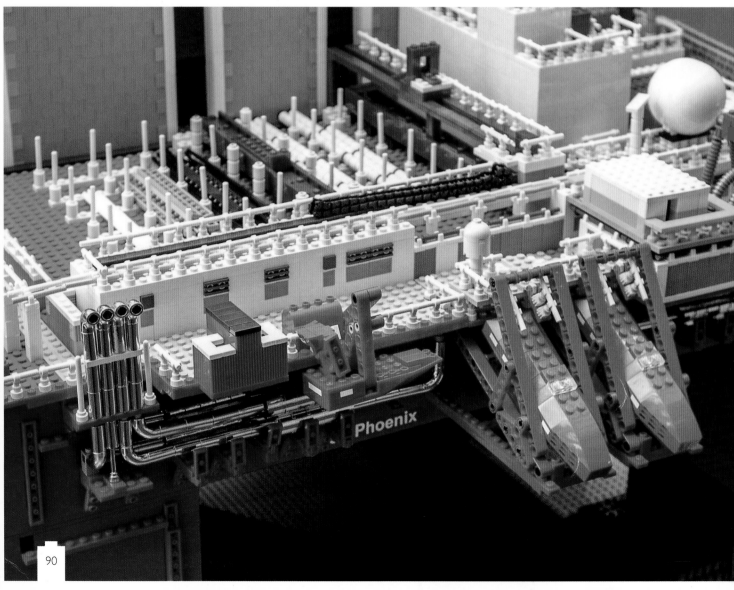

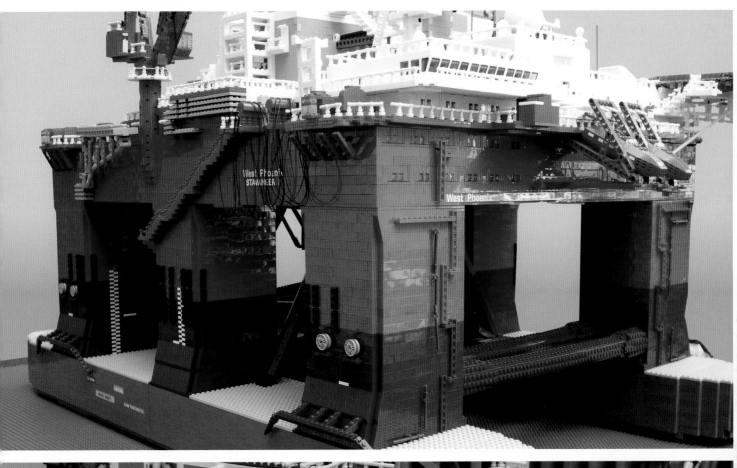

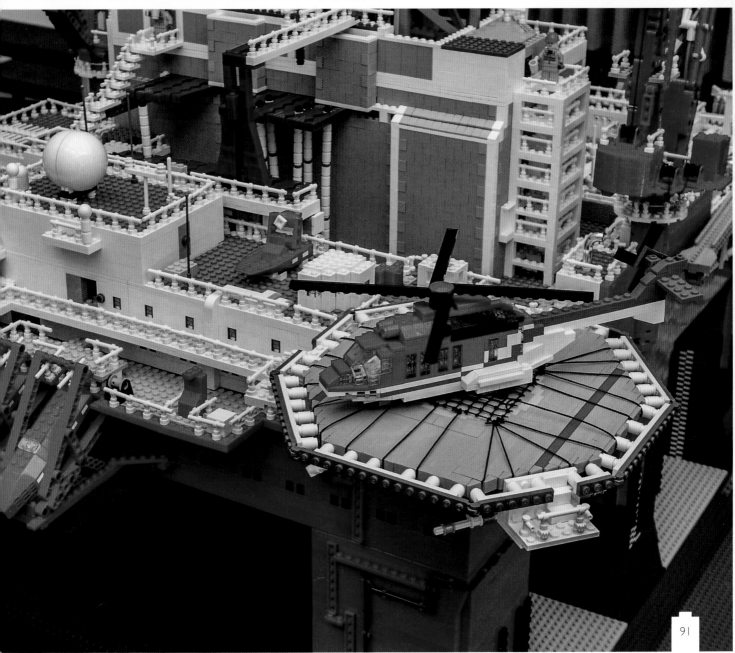

WELCOME TO THE TREE TOWN!

When New York-Presbyterian Hospital wanted something for its lobby, Japanese LEGO® artist Sachiko Akinaga created this unique, whimsical fantasy world.

Akinaga's build was designed to allow patients and visitors to the hospital—as well as the healthcare staff—to take a visual trip to an imaginary tree town. In addition to a zoo, a grocery store, and other levels on the tree, the model features a spiral railway that can transport "visitors" to every area of the town. This proved to be the most challenging part of the near-5-foot build, as Akinaga had to make the track from scratch.

In total, it took the Japanese artist around 300 hours to complete the layered build using 40,000 bricks. As the model was destined to go on permanent display in the hospital's lobby, Akinaga chose to glue it together; this also made it more robust when it accompanied her from her home in Tokyo on her first trip to New York City, where it was to be installed.

Builder: Sachiko Akinaga
Dimensions: 2½ ft. x 2½ ft. x 5 ft.
Build time: 300 hours
Location: Japan

40,000

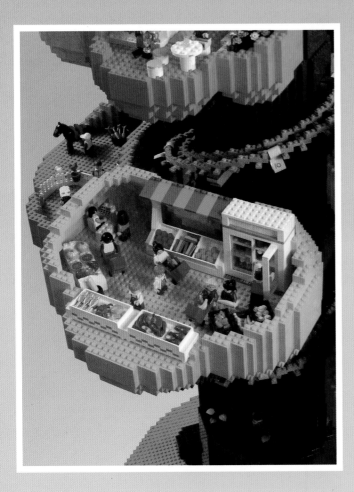

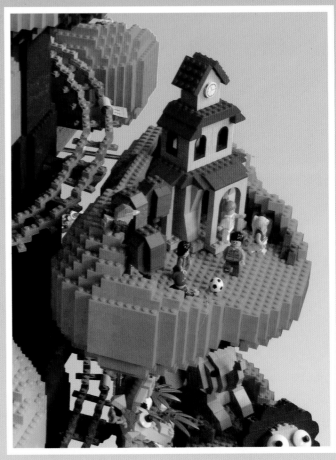

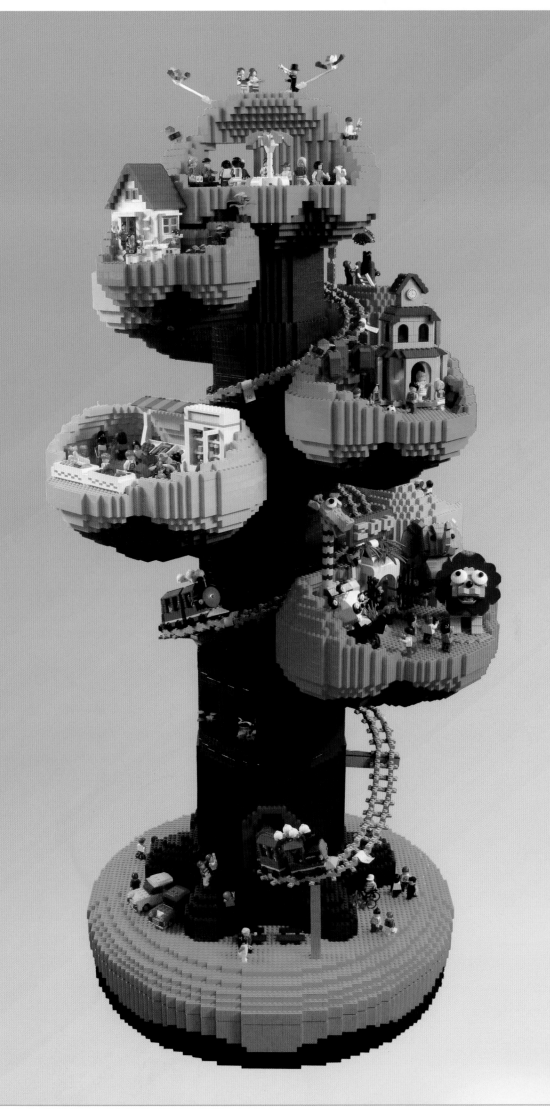

GIANT EGYPTIAN SPHINX

When Robin Sather was asked to create a large-scale model to complement an Egyptian-themed LEGO® exhibition he turned to DUPLO® blocks for his build.

This is not the first time Sather has used LEGO Group's "large format" DUPLO blocks for a sculpture, although the *Giant Egyptian Sphinx* is the largest project he has undertaken in this way. In this instance his choice of the bigger blocks was essential, as Sather not only needed to build something large and imposing to guard the entrance to the touring *Secrets of the Pharaohs* exhibition, but he also had to perform a "live" brick-by-brick build in front of the crowds at each new venue. To compound things, there was a time limit to his build: the statue had to be finished within three days of the show opening.

Using DUPLO blocks enabled Sather to deliver on all counts. With just one or two assistants he could build the towering 8-foot-tall model from the ground up within the allotted time—something that would simply have been impossible to achieve using "regular" LEGO bricks.

To help with the build process, Sather made a half-size version of the model to work from; or, more specifically, he made *half* of a half-size version. Because his sphinx is bilaterally symmetrical, the pro builder realized he only needed to make one side of the half-sized model. Once that was built, he could place a mirror behind it to create the illusion of the full model. This neat time- and space-saving trick then gave him a perfectly symmetrical reference for his big build!

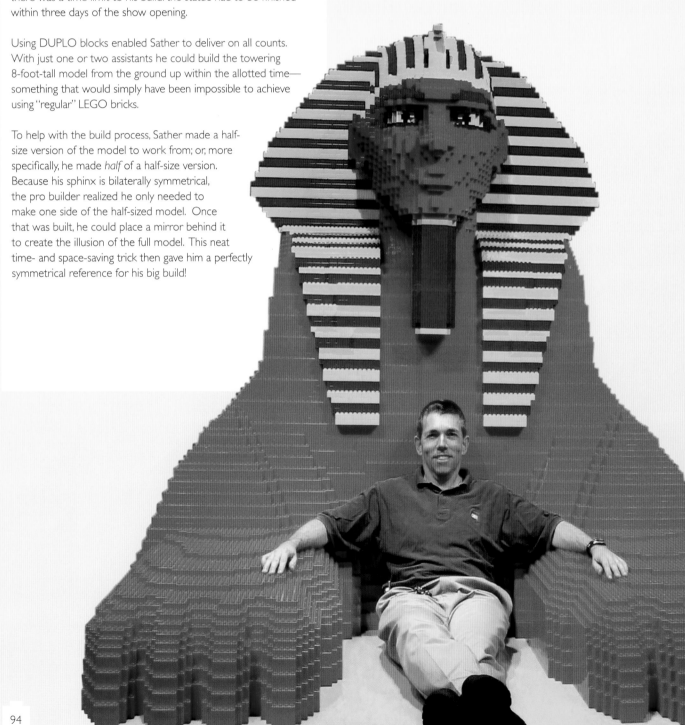

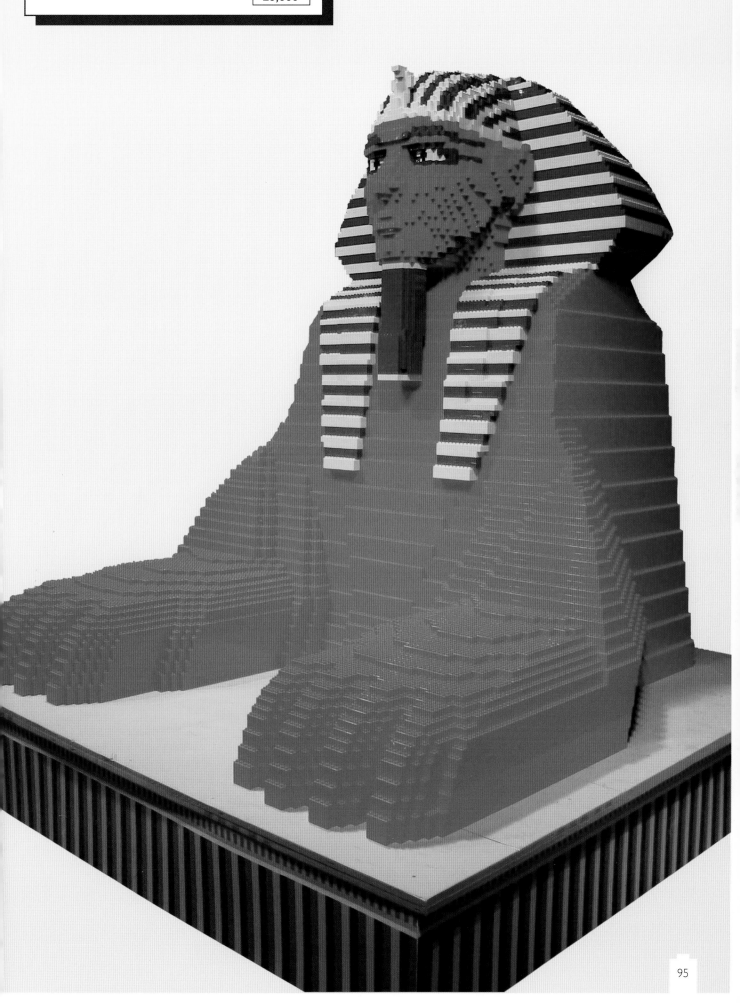

Builder: Robin Sather
Dimensions: 8¼ ft. x 7¾ ft. x 7¾ ft.
Build time: 3 days
Location: Canada

25,000

GOLDEN GATE BRIDGE

When it opened in 2016, visitors to the **Brick by Brick** *exhibition at Chicago's Museum of Science and Industry couldn't miss Adam Reed Tucker's 60-foot Golden Gate Bridge.*

There are numerous block-based variations on the theme of famous bridges. Some are larger than Tucker's, and some are richer in detail—but very few are as *authentic*. Tucker's pared-back build style doesn't feature brick-perfect detailing, but what the architect-turned-LEGO® professional does instead is capture the *essence* of the structure.

One of the most remarkable parts of this build is that the bridge is fully functional and none of it is glued. From the weight of the anchorage points at either end to the studless Technic beams that form the main cables, every element has been extensively researched, tested, and designed to provide both form and function. In essence, this is a self-supporting suspension bridge, just like the structure it is based on.

Although there are transparent stands beneath the bridge's 40-foot span, they are purely precautionary: no one has tested LEGO for "creep" (the effect of gravity on a material over time) or explored the long-term performance of the beam joints, so there was no way of knowing how the bridge would react to being on display in an exhibition that was initially set to run for a year. It is perhaps just as well they are in use, as *Brick by Brick* was subsequently extended due to its popularity!

Builder: Adam Reed Tucker
Dimensions: 60 ft. x 1 ft. x 5 ft.
Build time: 400 hours
Location: U.S.

350,000+

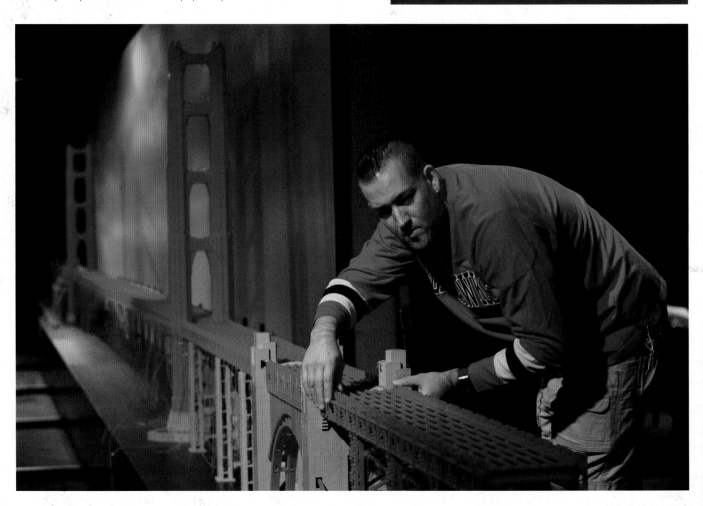

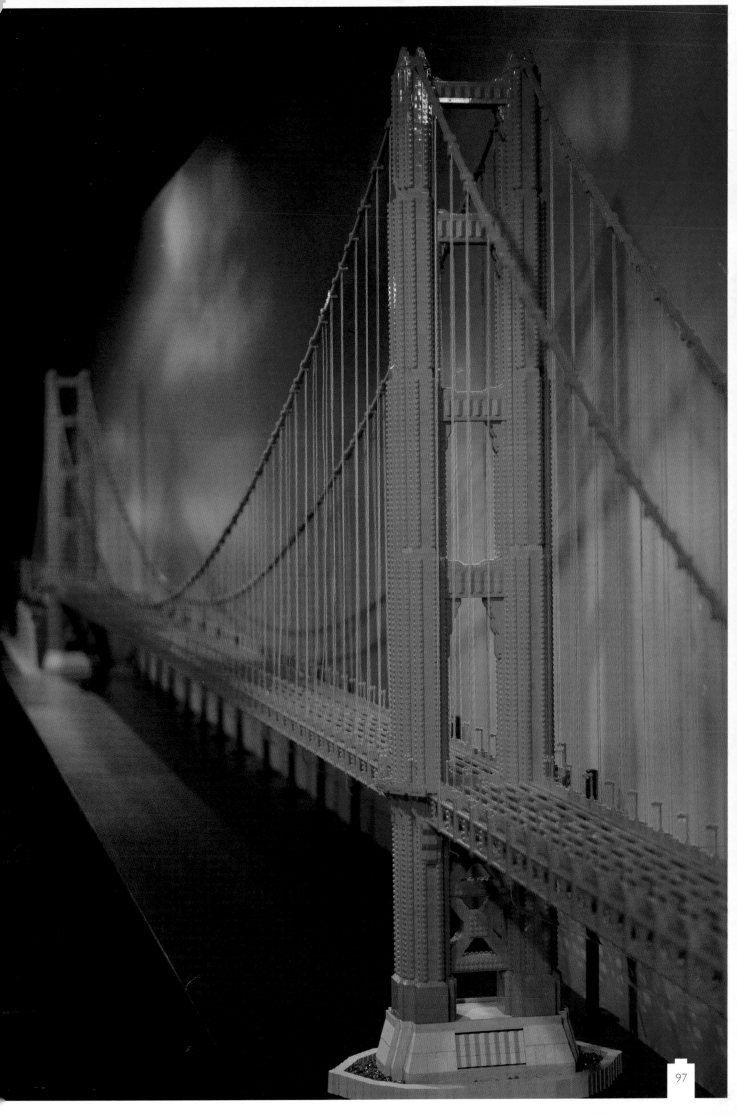

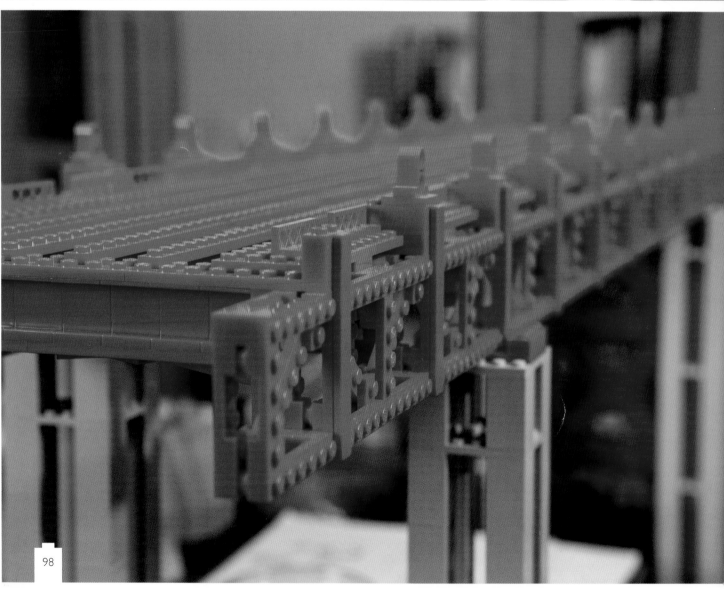

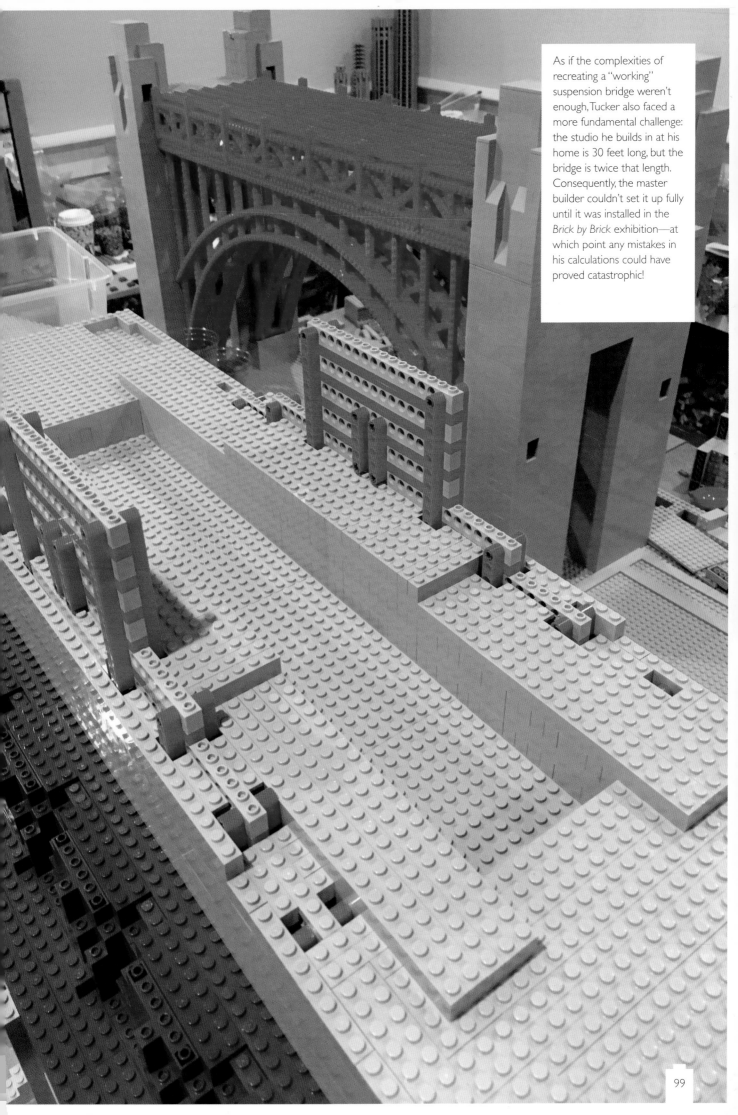

As if the complexities of recreating a "working" suspension bridge weren't enough, Tucker also faced a more fundamental challenge: the studio he builds in at his home is 30 feet long, but the bridge is twice that length. Consequently, the master builder couldn't set it up fully until it was installed in the *Brick by Brick* exhibition—at which point any mistakes in his calculations could have proved catastrophic!

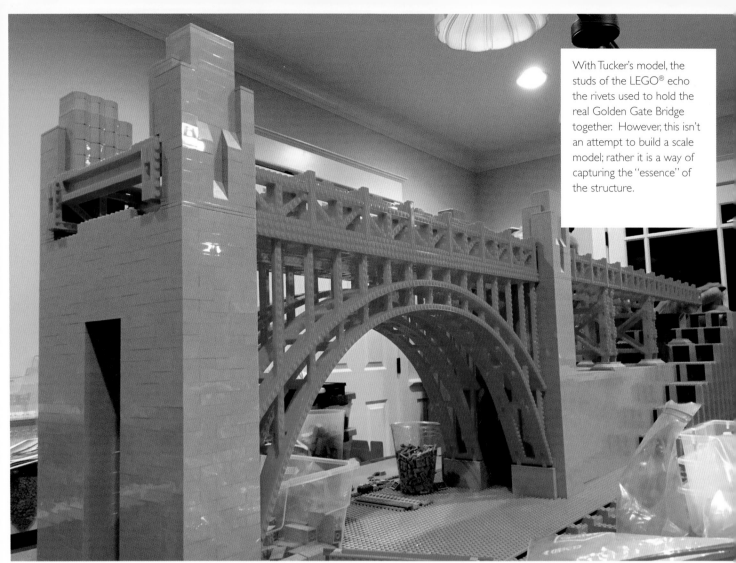

With Tucker's model, the studs of the LEGO® echo the rivets used to hold the real Golden Gate Bridge together. However, this isn't an attempt to build a scale model; rather it is a way of capturing the "essence" of the structure.

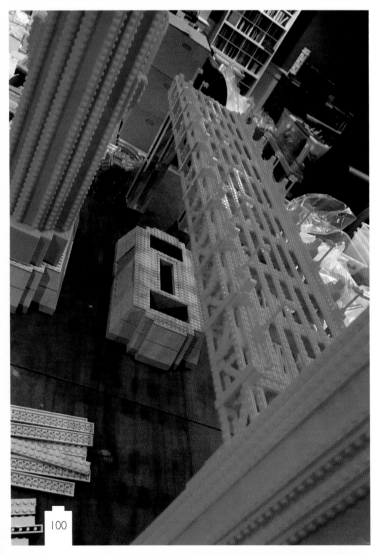

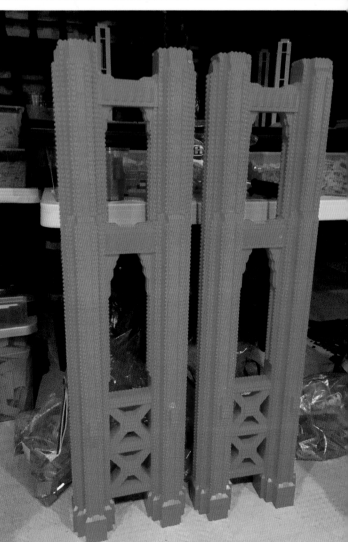

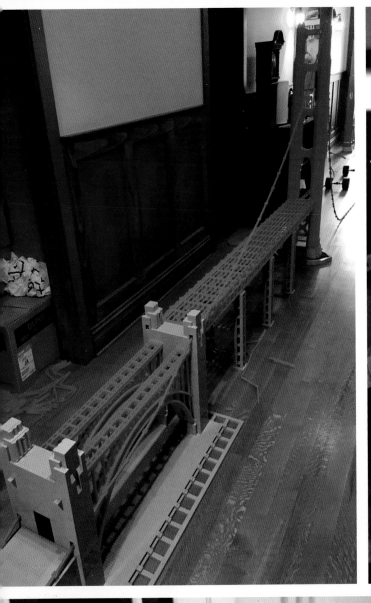

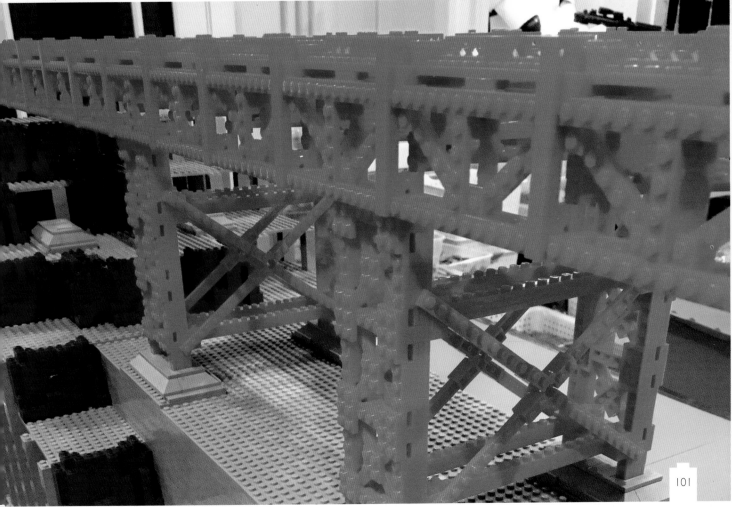

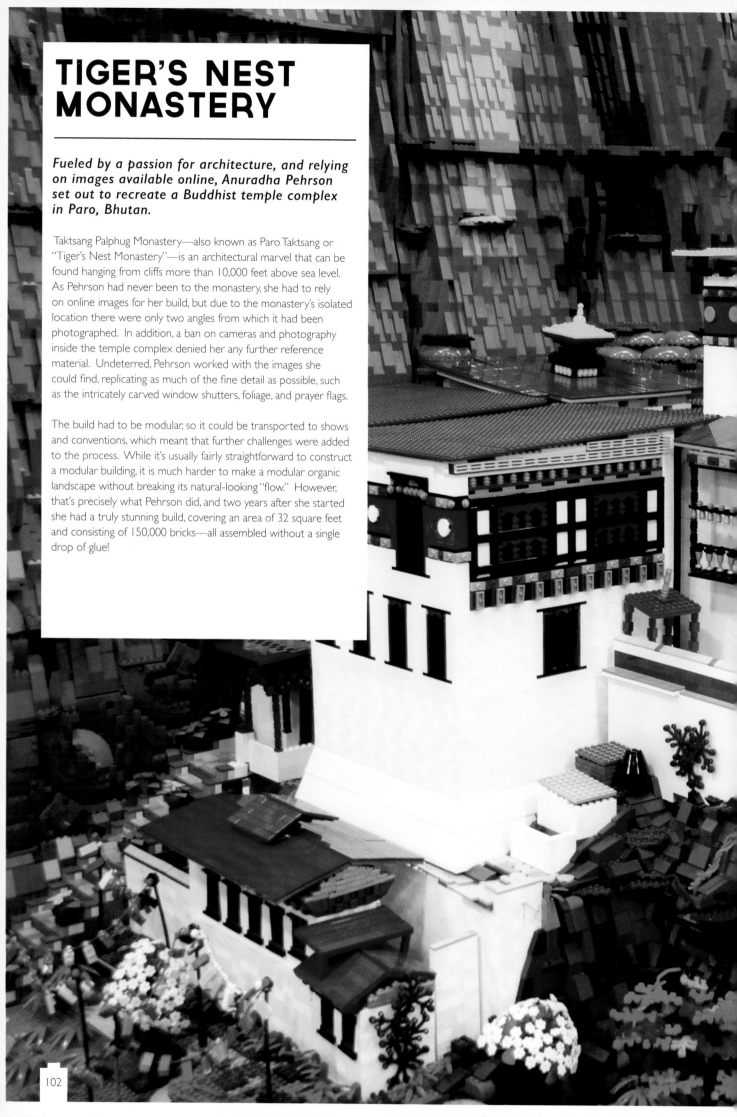

TIGER'S NEST MONASTERY

Fueled by a passion for architecture, and relying on images available online, Anuradha Pehrson set out to recreate a Buddhist temple complex in Paro, Bhutan.

Taktsang Palphug Monastery—also known as Paro Taktsang or "Tiger's Nest Monastery"—is an architectural marvel that can be found hanging from cliffs more than 10,000 feet above sea level. As Pehrson had never been to the monastery, she had to rely on online images for her build, but due to the monastery's isolated location there were only two angles from which it had been photographed. In addition, a ban on cameras and photography inside the temple complex denied her any further reference material. Undeterred, Pehrson worked with the images she could find, replicating as much of the fine detail as possible, such as the intricately carved window shutters, foliage, and prayer flags.

The build had to be modular, so it could be transported to shows and conventions, which meant that further challenges were added to the process. While it's usually fairly straightforward to construct a modular building, it is much harder to make a modular organic landscape without breaking its natural-looking "flow." However, that's precisely what Pehrson did, and two years after she started she had a truly stunning build, covering an area of 32 square feet and consisting of 150,000 bricks—all assembled without a single drop of glue!

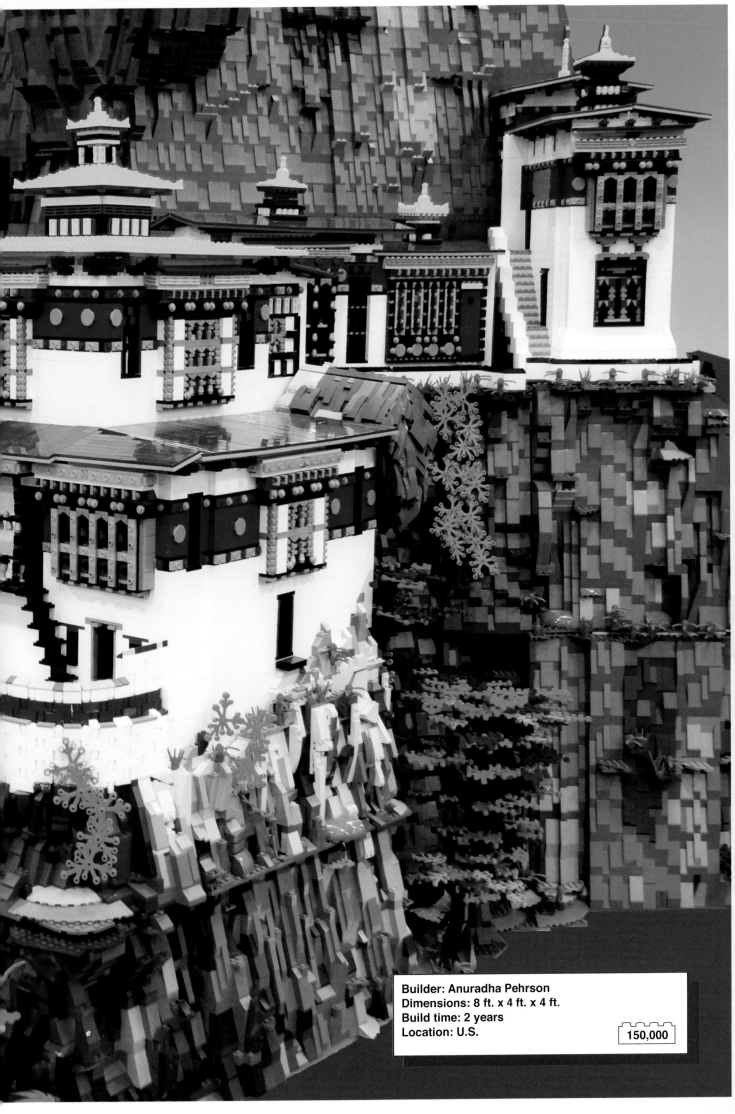

Builder: Anuradha Pehrson
Dimensions: 8 ft. x 4 ft. x 4 ft.
Build time: 2 years
Location: U.S.

150,000

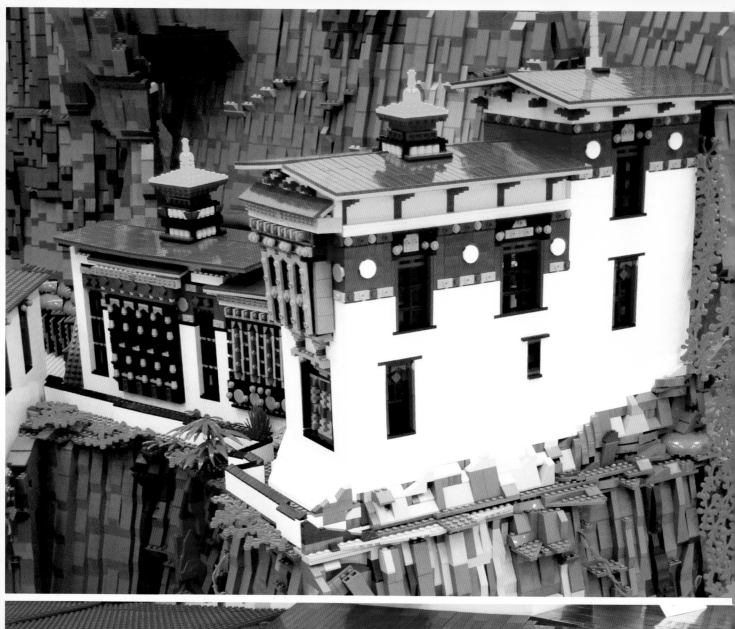

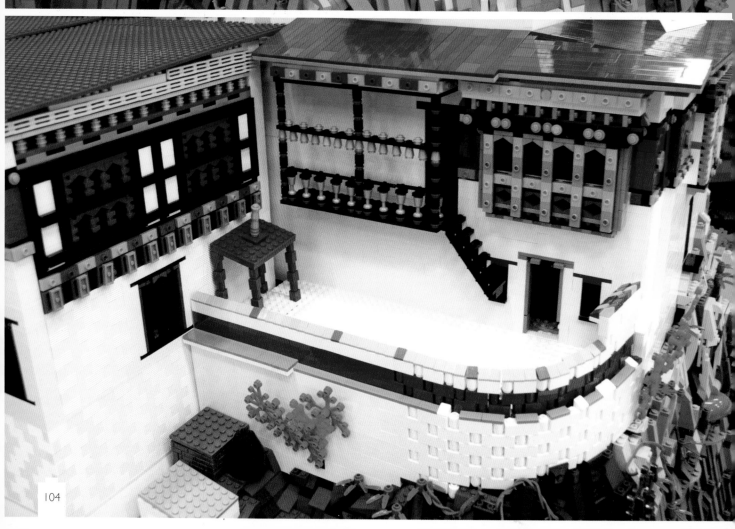

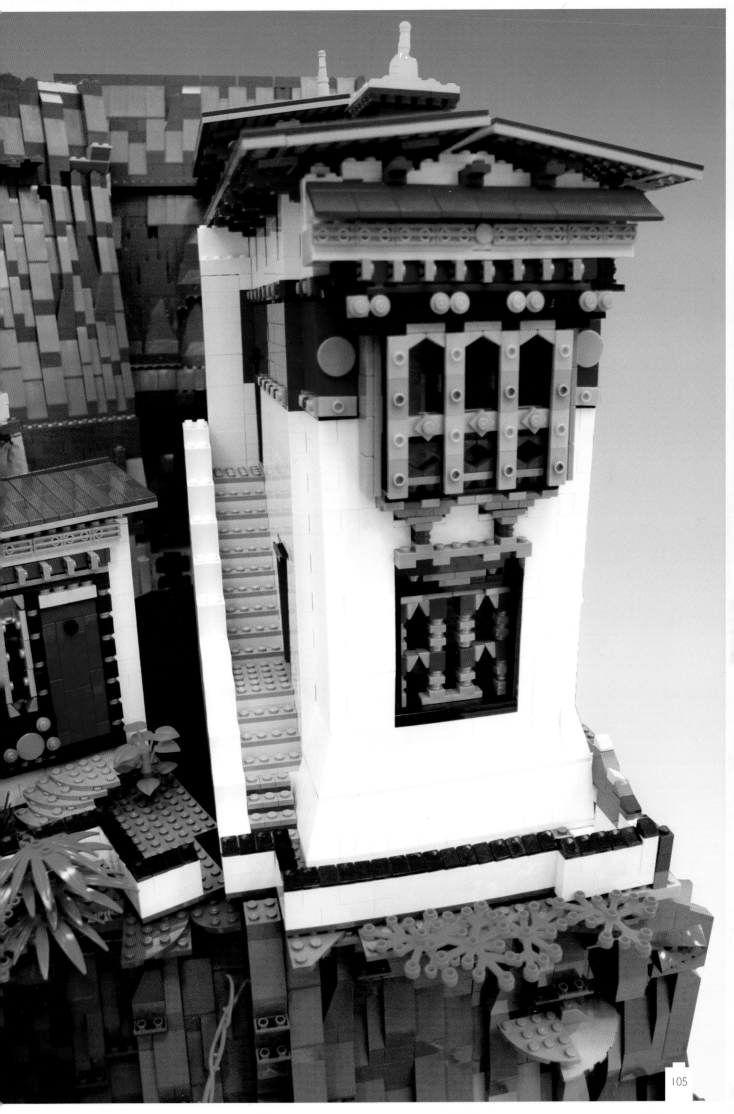

DINOSAUR
SKELETON

*Nathan Sawaya's **Dinosaur Skeleton** was built with one very clear purpose in mind: to give something back to the kids who were entering museums and being introduced to the art world through his **The Art of the Brick®** exhibitions.*

Because kids love dinosaurs, a Tyrannosaurus rex skeleton seemed the perfect choice for his model, although it required plenty of research into T. rex anatomy to ensure the sculpture looked "right." Sawaya even purchased a 3-foot-tall T. rex skeleton maquette that sat on his desk during the build process to serve as a constant reminder of his goal.

However, even with this preparation, the build process was demanding. It took Sawaya a total of three months to create the 20-foot structure, during which time he glued together more than 80,000 bricks to create fourteen separate sections that could be assembled easily on site. The sheer amount of time—not to mention the repetitive nature of building countless ribs and bones from primarily tan bricks—became very tedious, but Sawaya kept on building, knowing that the result would be worth it. As Sawaya says, referencing his previous career: "the worst day as an artist is still better than the best day as an attorney!"

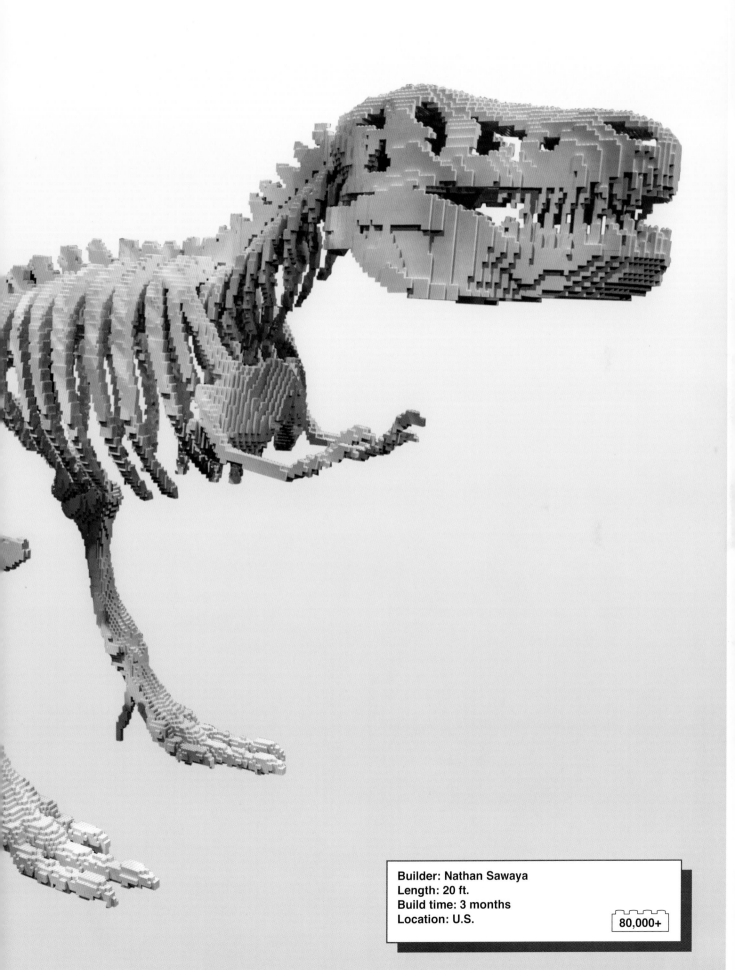

Builder: Nathan Sawaya
Length: 20 ft.
Build time: 3 months
Location: U.S.

80,000+

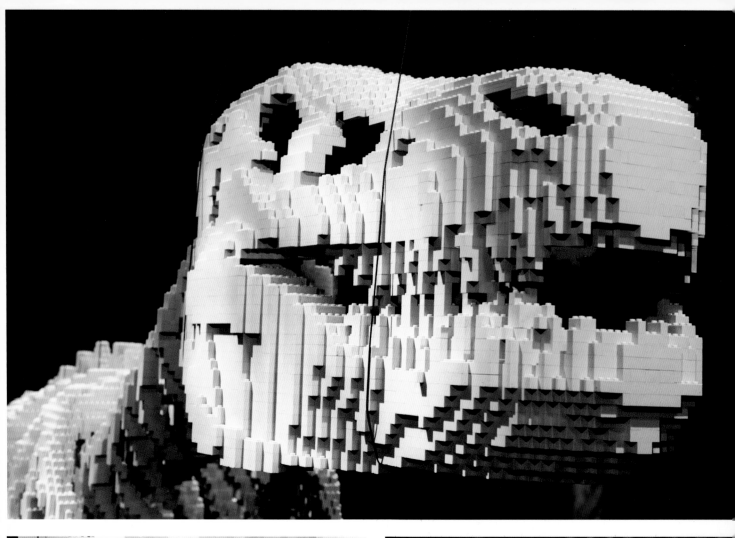

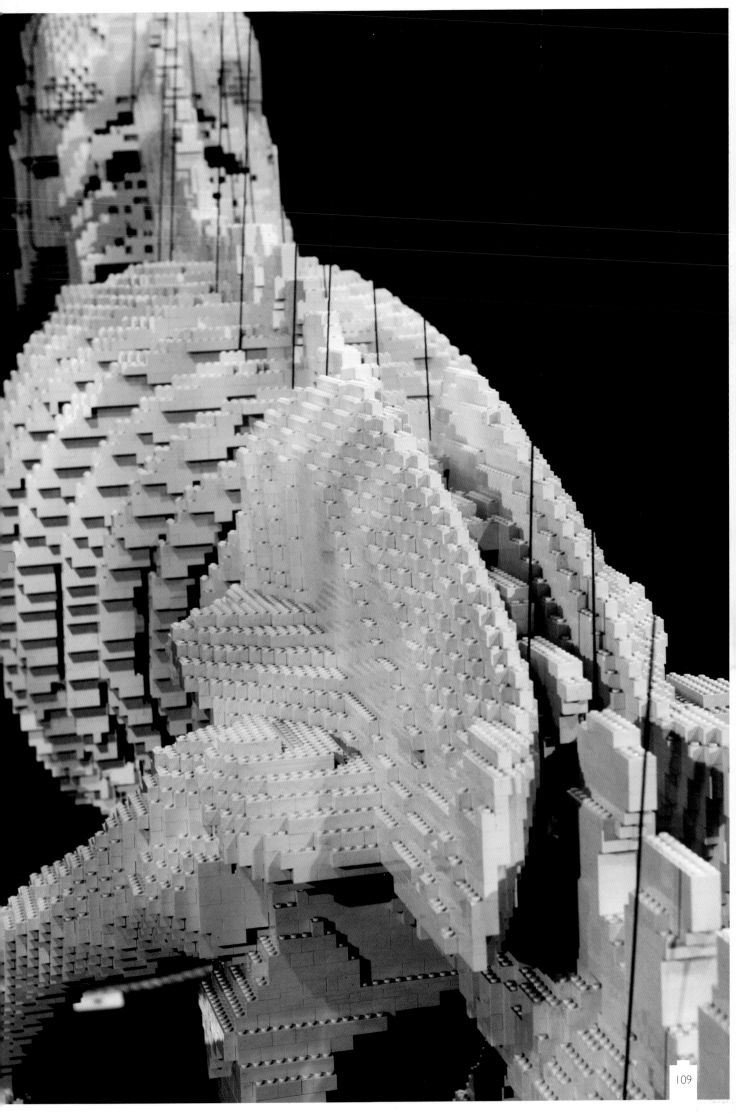

PICTURE CREDITS

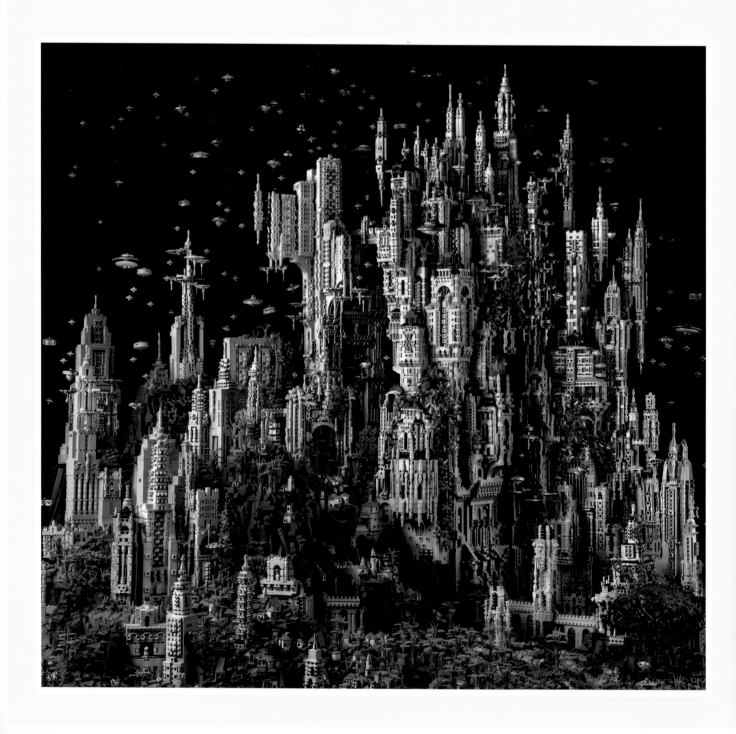

CONTRIBUTOR DIRECTORY

Big Yellow
Nathan Sawaya
www.brickartist.com

Halifax Discovery Center Mosaic
Robin Sather
www.brickville.ca

Victorian Heap
Mike Doyle
www.mikedoylesnap.blogspot.com

Roman Colosseum
Adam Reed Tucker
www.brickstructures.com

Samurai Code
Ben Pitchford
www.flickr.com/photos/127491317@N08
ideas.lego.com/projects/142449

Green Dragon
Sachiko Akinaga
www.lets-brick.com

LEGO® Harpsichord
Henry Lim
www.henrylim.org

Millennial Celebration
Mike Doyle
www.mikedoylesnap.blogspot.com

USS Missouri ("Mighty Mo")
Jim McDonough
www.moc-pages.com/home.php/57665

Metaphorical Horizons
Lene Rønsholt Wille
www.lenewille.dk

Batmobile
Nathan Sawaya
www.brickartist.com

The Forbidden City
Andy Hung
www.andyhung.com

Tarzan Versus the Lion
Douglas Dreier & Shyam Bahadur
www.facebook.com/DumbAsABrickCreations

Unchain My Heart
Paul Hetherington
www.flickr.com/photos/14964802@N07

The Collectivity Project
Olafur Eliasson
www.olafureliasson.net

Ohio Stadium
Paul Janssen
www.moc-pages.com/home.php/336

A Bear In His Natural Habitat
Brandon Griffith
www.flickr.com/photos/brandongriffith

American Eagle Roller Coaster
Adam Reed Tucker
www.brickstructures.com

Containment
Tyler Clites & Nannan Zhang
www.flickr.com/photos/legohaulic
www.flickr.com/photos/nannanz

Universal Explorer LL2016
Mark Neumann
www.flickr.com/photos/snowleopard

Point Dume Residence
César Soares
www.flickr.com/people/124546590@N03

RMS Queen Mary
Ed Diment & Bright Bricks
www.bright-bricks.com

Oversize LEGO® Chair
Alê Jordão
www.alejordao.com

West Phoenix Oil Platform
Matija Puzar
www.matija.no

Welcome to the Tree Town!
Sachiko Akinaga
www.lets-brick.com

Giant Egyptian Sphinx
Robin Sather
www.brickville.ca

Golden Gate Bridge
Adam Reed Tucker
www.brickstructures.com

Tiger's Nest Monastery
Anuradha Pehrson
www.flickr.com/photos/anupehrson/

Dinosaur Skeleton
Nathan Sawaya
www.brickartist.com

Thunder Bay Press
An imprint of Printers Row Publishing Group
10350 Barnes Canyon Road, Suite 100
San Diego, CA 92121
www.thunderbaybooks.com

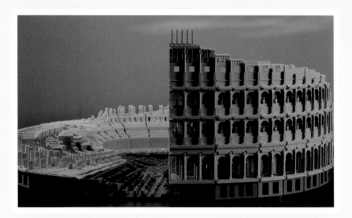

The book was conceived, designed, and produced by
Quintet, an imprint of The Quarto Group
58 West Street
Brighton
BN1 2RA
United Kingdom

QTT.GLEG

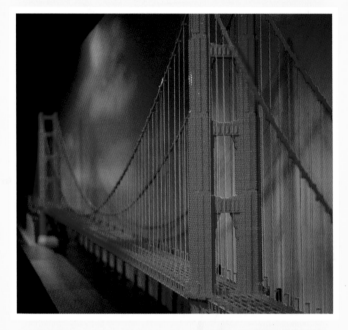

Thunder Bay Press
Publisher: Peter Norton
Publishing Team: Ana Parker, Kathryn Chipinka, Aaron Guzman
Editorial Team: JoAnn Padgett, Melinda Allman, Traci Douglas

Quintet, an imprint of The Quarto Group
Designers: Gareth Butterworth, Michelle Rowlandson,
 Ginny Zeal, Ian Miller
Writer: Chris Gatcum
Project Editors: Chris Gatcum, Leah Feltham, Caroline Elliker
Editorial Director: Emma Bastow
Publisher: Mark Searle

ISBN: 978-1-68412-166-3

Printed in China

21 20 19 18 17 1 2 3 4 5

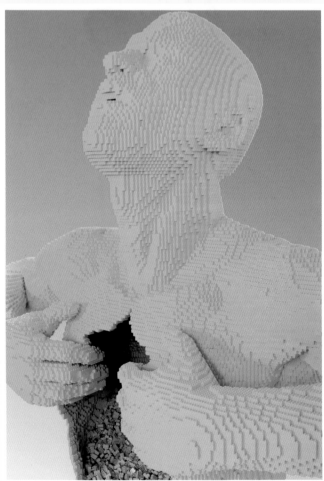